MUSEUMS IN BRITAIN: A HISTORY

Christine Garwood

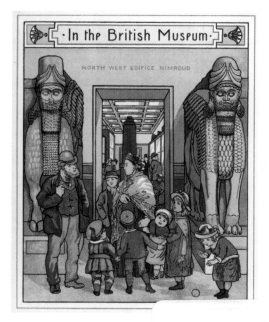

SHIRE PUBLICATIONS

Published in Great Britain in 2014 by Shire Publications
Ltd, PO Box 883, Oxford, OX1 9PL, UK
PO Box 3985, New York, NY 10185-3985, USA
E-mail: shire@shirebooks.co.uk www.shirebooks.co.uk

A CIP catalogue record for this book is available from the
British Library.

Shire Library no. 703. ISBN-13: 978 0 74781 196 1
PDF ebook ISBN: 978 0 74781 502 0
e-pub ISBN: 978 0 74781 501 3

Christine Garwood has asserted her right under the
Copyright, Designs and Patents Act, 1988, to be identified
as the author of this book.

Designed by Tony Trucott Designs, Sussex, UK and typeset
in Perpetua and Gill Sans.

Printed in China through Worldprint Ltd.

14 15 16 17 18 10 9 8 7 6 5 4 3 2 1

COVER IMAGE
Cover design and photography by Peter Ashley. Front
cover: Display cabinet and drawers at the Pitt Rivers
Museum, Oxford. Back cover: Black Country Museum
badge, collection Biff Raven-Hill.

TITLE PAGE IMAGE
Working-class access to Victorian and Edwardian public
museums was encouraged by changing patterns of work
and leisure, as well as improved levels of education
and literacy.

CONTENTS PAGE IMAGE
Old-fashioned display of objects in the Victoria & Albert
Museum, Kensington.

ACKNOWLEDGEMENTS
For Lucy, Laura and Dave and all at the Ironbridge
Institute.

PHOTOGRAPH ACKNOWLEDGEMENTS
I would like to thank Lucy Hockley, James Morley, Sara
Priddle, Brian Radam and Helen Mason for their help
with images.

Images are credited as follows:

AFP/Getty Images, page 57; British Lawnmower
Museum, page 42 (left and right); M. Chohan, page
32; Mary Evans Picture Library, pages 1, 15 (bottom),
18, 19 (top right and top left), 22 (bottom), 26, 27
(top); Mary Evans Picture Library/Seat Archive/Alinari
Archives, reproduced with the permission of Ministero
per i Beni e le Attività Culturali, page 10; © Ashmolean
Museum/Mary Evans, pages 13 (top left and top right),
14 (top); Mary Evans/Natural History Museum, pages
34, 35; © Illustrated London News Ltd/Mary Evans,
page 33 (top); National Trust Photographic Library/
Dennis Gilbert/The Bridgeman Art Library, page
48; National Trust Photographic Library/Andreas von
Einsiedel/The Bridgeman Art Library, page 49; Robert
Opie, page 40; PA Photos/TopFoto, page 4; Russell
Butcher, page 37; Andres Rueda, page 50; Ryedale Folk
Museum, page 58; © Transport for London, page 9;
Travel21 Impact/Heritage Images/TopFoto, page 23;
Victoria & Albert Museum, page 8; Wayside Museum, page
41; Weald and Downland Museum, pages 46, 56.

All other images from the author's collection.

Shire Publications is supporting the Woodland Trust, the UK's leading woodland conservation charity, by funding the dedication of trees.

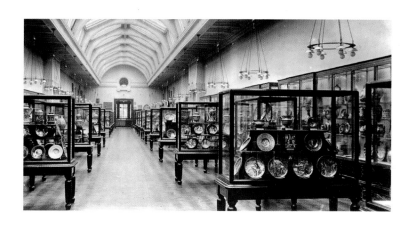

CONTENTS

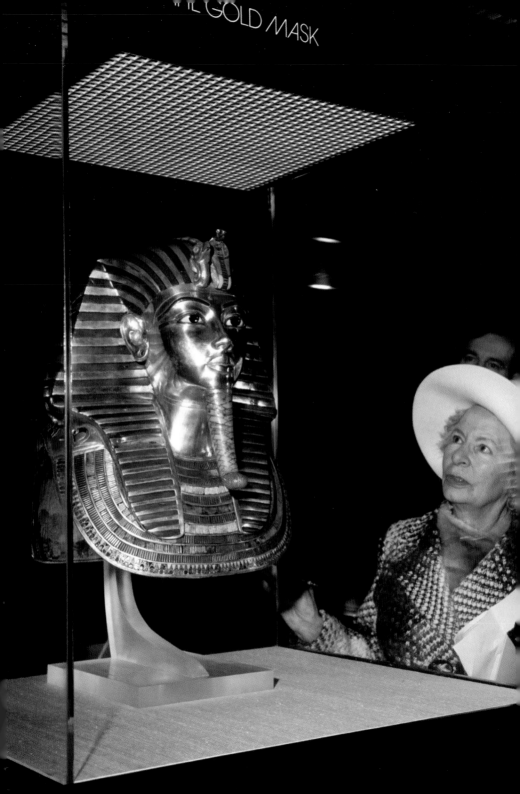

INTRODUCTION

'A museum is a non-profit, permanent institution in the service of society and its development, open to the public, which acquires, conserves, researches, communicates and exhibits the tangible and intangible heritage of humanity and its environment for the purposes of education, study and enjoyment.'
International Council of Museums

'Museums enable people to explore collections for inspiration, learning and enjoyment. They are institutions that collect, safeguard and make accessible artefacts and specimens, which they hold in trust for society.'
Museums Association

IN NOVEMBER 2012, London's Victoria and Albert Museum announced that its next blockbuster exhibition would be 'David Bowie Is,' an international retrospective of the innovative musician and cultural icon across five decades, benefitting from unprecedented access to his private archive. In the week leading up to the exhibition's opening, it became clear that this had become the fastest-selling spectacle in the museum's history, with in excess of forty-two thousand timed tickets sold to the public in advance, outstripping the populations of the Shetland and Orkney Islands combined and more than doubling the number of such sales for previous exhibitions. Bowie's popularity and influence aside, the episode demonstrates not only the increasing appeal of museums and their place in contemporary culture, but also – just as sharply – their changing role. Although the exhibition was the latest in a line of London blockbusters, from 'Manet' to 'Pompeii', and museums have always collected and displayed the work of the contemporary and cutting edge, the sheer level of public interest and access illustrates the extent to which Britain's cultural institutions have developed over the last five hundred years. From the boltholes of connoisseurs and collectors to a source of gossip for tabloids, museums have retained much of their

Opposite:
The crowds that packed the British Museum's blockbuster 'Treasures of Tutankhamun' exhibition in 1972 reflect the enduring appeal of museums and their central place in learning, research and scholarship as well as popular culture.

Museums and galleries can be found in a vast array of venues, big and small. Pictured here are the Museum of London at London Wall (top right), Southampton's recently restored Tudor House Museum (middle), the Bowes Museum at Barnard Castle (bottom), County Durham and the original museum of taxidermist Walter Potter (1835–1918), in Bramber near Steyning, Sussex (top left). Mr Potter's Museum of Curiosities, as it was known, was based on his collection of stuffed animals often set in detailed dioramas such as 'Rabbit School' and 'The Original Death and Burial of Cock Robin.' By the mid-1980s, the collection had moved to Jamaica Inn, Cornwall, before being dispersed by auction in 2003, sparking public outcry.

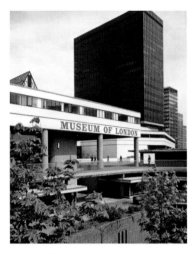

Bowes Museum, Barnard Castle

fundamental purpose while their role has in many ways been transformed. This book, albeit short, is an attempt to trace this story through a portrait of some of the major institutions, obscure enthusiasts and overarching trends that have served to shape the history of museums in Britain from the sixteenth century to the twenty-first.

From Liskeard to London, museums have become a key feature of the British cultural landscape, representing a host of subjects and passions developed by people and communities over time. With topics ranging from fans and lawnmowers to football and priceless art, museums can be found in almost every conceivable location – village or town, abandoned church or even disused sardine factory, reflecting our fundamental desire to 'collect, safeguard and make accessible artefacts and specimens' (Museums Association, 1998). While museums have their place as 'repositories of curiosities', as described in the 1836 edition of Samuel Johnson's *Dictionary of the English Language*, they are now also virtual – venues without walls where visitors may have no immediate contact with objects at all. Whether they be esoteric or high-tech, the story of museums is therefore the story of human progress: our interests, our fascinations and our interpretations of our own history, in the context of broader developments and shifts.

The word 'museum' itself has ancient roots, originating from the Greek Μουσεῖον (*Mouseion*), a place or shrine dedicated to the Muses, the nine mythological guardians of history, astronomy and the arts. The word is most famously associated with the *Musaeum* of Alexandria (including the Library of Alexandria) established by Ptolemy I Soter or Ptolemy II Philadelphus in *c.* 280 BCE for music, poetry, philosophy and research, similar in purpose to a modern university. The actual practice of collecting dates back to the oldest civilisations however – to ancient Babylon and the private collections of rare or curious natural objects and artefacts such as Ennigaldi Nanna's museum of Mesopotamian antiquities dating from *c.* 530 BCE.

While the practice of collecting is age-old, the word 'museum' was not used in English to mean a collection or building to display objects until the mid-seventeenth century, when it was applied to botanist and gardener John Tradescant (*c.* 1570–1638) and son's dazzling 'collection of rarities', which by various twists became the basis of the University of Oxford's Ashmolean Museum (1683). The extraordinary hoard, a wonder for contemporaries, originated in Tradescant the elder's work travelling in Europe and North Africa looking for new types of plants to bring back for his employers in England, including the apricot, lilac and acacia trees. His search and his 'ark' – as the Tradescants' treasure-filled Lambeth home was known – underscores a deeper point: museums can originate from any number of human activities from passion to plunder, trading to religious mission, voyages of discovery or of conquest, scientific study, obsession or simple greed.

Tradescant's Ark also highlights the way in which museums can cover a whole host of subject matter, often under a single roof – arts, archaeology, anthropology and ethnology, history, the military, science, technology, industry, childhood, natural history and more –

Early twentieth-century cigarette card depicting the etymology of the word 'museum' from a place or shrine dedicated to the nine muses of Greek mythology. Museums in Britain fulfil a vital social function, both reflecting and shaping the story of the nation, and our collective understanding of the past.

Vintage collection guide from the Victoria and Albert Museum. In recent decades museums have widened their focus from high culture, connoisseurship and antiquarianism to popular culture, audience development and access. 'Access' includes ease of physical access as well as ease of understanding. Changing ideas about inclusivity have impacted sharply on exhibition practice.

VICTORIA AND ALBERT MUSEUM

ROMAN-ESQUE ART

H. M. STATIONERY OFFICE: 1s0d NET

with seemingly unending degrees of specialisation and novelty. More than anything, museums are places that organise knowledge to some extent; they are able to interpret and represent reality in manifold ways. For this reason they have frequently been criticised for reflecting a dominant ideology, whether that ideology be imperialist, capitalist, male or middle class. Museums then are neither mere storehouses nor communicators of pure unadulterated fact, but complex social and cultural entities in themselves. While Britain's museums have experienced two notable booms – in the 1880s and 1980s – the second (when it is estimated that more than two new museums were opening a week) was even accompanied by criticisms of a 'heritage industry' where history itself had become a commodity, embellished and exploited for financial gain.

Power and profit aside, museums remain a cornerstone of British culture and their popularity has spiralled in recent years despite repeated battering by funding cuts. A 2009 Museums Association study estimated that there were in excess of 100 million visits a year to the nation's 2,500 British museums and galleries, while eight of the top ten visitor attractions in Britain were museums of different types. Besides caring for collections and promoting understanding of the nation's past, the study also pointed to wider social benefits of museums and their valuable contribution in promoting well-being and quality of life. Order is often created by the classification of museums depending on ownership, management and funding. The first main category is national museums, generally larger institutions that have collections considered to be of national importance and which receive funding from central government. Across the nation, these

Money, money, money. Visitors and the revenue that they generate through ticket sales and gift shops are essential to the survival of museum and gallery sites which have been forced to commercialise in recent decades, becoming competitive, market-driven institutions concerned with marketing, management and brand.

are complemented by local authority museums owned and run by town, borough, city or county councils with collections relevant to local history and heritage; and independent museums overseen by independent charities and other independent bodies and trusts. Other major types include university museums, with collections sometimes connected to specific areas of academic interest and research, while regimental museums and armouries managed by the armed forces preserve collections relating to military heritage. These more traditional, often purpose-built institutions are joined by historic properties including those run by English Heritage and the National Trust, which also hold and display collections of historic interest. Even zoological parks and botanic gardens, though outside the confines of this book, could be loosely termed museums, as they collect, display and interpret collections of animals and plants. In short, human interests breed collections and institutions far too numerous to cover here. What follows then is an introduction to some of the main themes and trends, places and personalities, in the long and sometimes curious history of museums and galleries in Britain and the people who brought them to life.

Museums, galleries and historic houses are vital to heritage tourism, a major contributor to the UK economy. While visitor numbers are paramount, critics have expressed concern about the commodification of the nation's heritage and the effect of economics on depictions of the past.

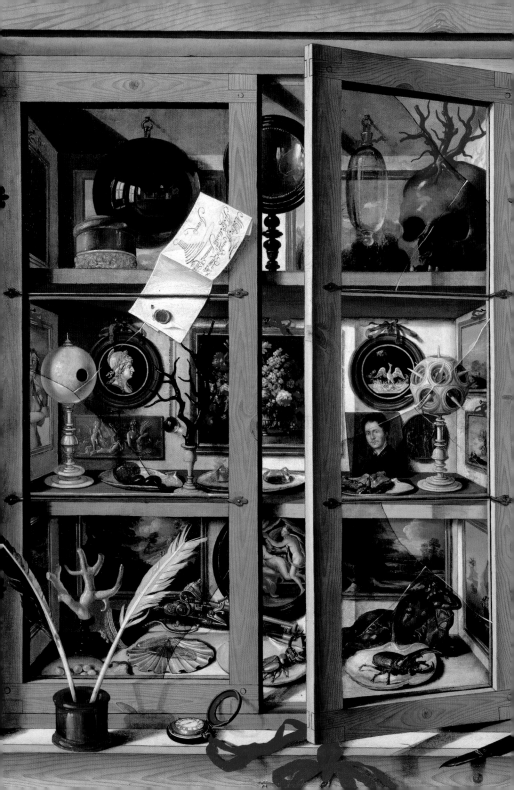

REPOSITORIES OF CURIOSITY

HOWEVER CURIOUS, the Tradescant 'Closet of Rarities' signalled an important turning point for the public museums and galleries of the future because anyone who could pay the required fee was able to access the 'ark', the level of payment being determined only by the length of the visit. Meanwhile, private collections were already well-established phenomena on the continent by the fifteenth and sixteenth centuries, with wealthy and powerful men such as the Medici and the Emperor Rudolf II in Prague amassing vast assemblies of rare and intriguing material in 'cabinets' or rooms of curiosity. The phenomenon was driven by the Renaissance and a revived spirit of inquiry in different fields, further boosted by developments in transport and trade. In the realms of intellect, a surge of interest in the classics drove individuals to collect the relics of classical antiquity, from medals to statues and manuscripts, while a growing spirit of investigation and empiricism fed the acquisition of objects from the natural world – curious animals, minerals and plants. These hoards, known as *Wunderkammern* (of marvels or curiosities), *Schatzkammern* (of jewels and precious metals) or *Kunstkammern* (of fine and decorative art), or most often simply as 'cabinets of curiosity', were encyclopaedic collections of objects unconstrained by categorical boundaries. From wonders of nature to objects of artifice, 'cabinets' or rooms spanned the limits of knowledge, encompassing what we would now know as natural history, geology, ethnography, archaeology, religion, history, antiquities and art. From corals, crystals, fossils and shells to the horns of unicorns (narwhals), skeletons of saints and dried dragon remains, the ultimate aim of the 'cult of curiosities' was to collect, preserve and display a microcosm of the whole of human knowledge. Nature could seemingly be controlled, and its different aspects analysed, through the careful acquisition and ordering of curiosities, each cabinet shaped by the interests of its creator. In the collections of aristocrats, scholars, connoisseurs and kings were to lay the roots of the modern museum, and new ways of seeing the world.

Opposite:
Scarabattolo by Domenico Remps (1641–c.99). Translated as 'Odds and Ends', the painting depicts the mix of curiosities found in cabinets of the era.

11

By the seventeenth century the rich and the learned of England, including Thomas Howard, Earl of Arundel (1586–1646) and physician and essayist Sir Thomas Browne (1605–82), were imitating their continental peers by amassing impressive collections of their own. Over time rational and scientific ways of seeing gradually superseded spectacles and wonder, and the emphasis of cabinets on the freakish, monstrous and bizarre. With collecting both fashionable and instructive, the author and philosopher Francis Bacon was of the opinion that every learned gentleman should have 'a goodly, huge cabinet', even establishing the idea of an institution of things to see and study in his *New Atlantis* (1627), which describes a great national museum of science and art. By this period Rome already had its first public collection, formed in 1471 when Pope Sixtus IV donated ancient bronze sculptures to the people and located them on Capitoline Hill. This was followed, in 1506, by the establishment of the Vatican Museums by Pope Julius II, originating in the public display of a recently unearthed ancient sculpture of Trojan priest Laocoön and his sons, but later to feature the vast collections of the Catholic Church.

It was not until 1660, however, that Britain was to see the opening of its first public museum, the Royal Armouries in the Tower of London. The collection was originally created after the death of Henry VIII when the contents of several royal armouries were removed to the tower where privileged visitors could view them privately. The Royal Armouries was finally opened to the public by Charles II, providing a timely display of the status and splendour of the English monarchy and its military prowess in the wake of the Restoration. Meanwhile in south London, horticulturalist collector John Tradescant the elder had died in 1638, with his son and namesake, John Tradescant the younger (1608–62), succeeding him as gardener to Charles I. John the younger was an avid collector in his own right, supplementing his father's work through New World voyages to Virginia returning with magnolia, bald cypress and tulip trees as well as American Indian and other curiosities including a cloak that allegedly belonged to Pocahontas' father, Powhatan. By this time, the South Lambeth 'ark' had become renowned across Europe, a must-see attraction for any cultivated traveller happening to visit the city of London. One regular visitor was the lawyer, antiquary, alchemist, astrologer, politician

The Royal Armouries or National Museum of Arms and Armour is the nation's oldest museum, with its roots in displays in the Tower of London, initially for visiting dignitaries but later for the paying public.

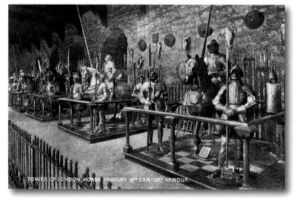

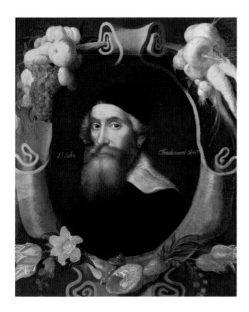

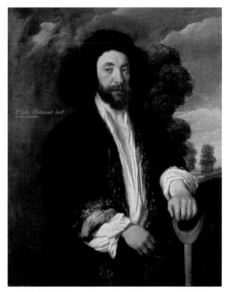

and founder member of the Royal Society, Elias Ashmole (1617–92). Ashmole, having developed a close, and some would say manipulative, friendship with Tradescant, offered to assist in cataloguing the vast collection (along with the physician Thomas Wharton) and to pay for publication of the book. The resulting catalogue, the *Musaeum Tradescantianum: or, A Collection of*

Above left: John Tradescant the Elder (*c.* 1570–1638), naturalist, gardener and collector, who used his foreign travels, including trips on behalf of his wealthy employers, to create a vast collection of rarities of his own.

Above: John Tradescant the Younger (1608–62), botanist, gardener and heir to his father's celebrated collection.

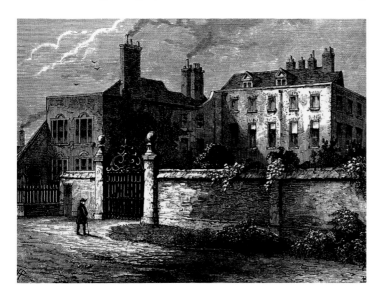

Left: Tradescant's 'Ark', home to the *Musaeum Tradescantianum* in South Lambeth. The boundary of the old 3-acre estate is marked today by Tradescant Road, Vauxhall.

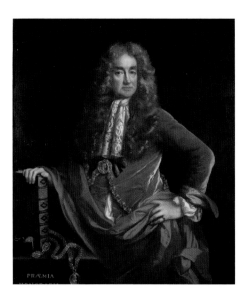

Rarities, Preserved at South Lambeth, near London (1656) was not only the first English use of the word museum in the modern sense, but also the country's first museum catalogue. The contents were nothing if not diverse: from 'Carvings, Turnings, Sowings, and Paintings' and Edward the Confessor's woollen gloves to the hand of a mermaid, the hand of a mummy and most famously 'a Dodar [Dodo] from the Island Mauritius; it is not able to flie, being so big'.

The friendship was set, and three years later, Tradescant signed a deed of gift to bequeath the collection to Ashmole, to be held in trust by his wife Hester while she was alive. Predictably, Tradescant's death heralded a vicious and protracted legal battle for ownership, with Ashmole even moving next door to Hester in Lambeth and convincing her to relinquish everything except the paintings. In 1678 she was found drowned in her garden pond, and his victory was complete. A few days later Ashmole noted in his diary: 'I removed the pictures from Mrs Tradescants House to myne'. Having already drawn up an agreement to give the collection (including his own material) to Oxford University, it was opened in 1683 as 'Ashmole's Repository' in a specially designed building in Broad Street, the basis of what we now know as the Ashmolean Museum. Ashmole's repository was a milestone: it is the first university museum and the oldest surviving purpose-built museum

Elias Ashmole (1617–92), antiquary and politician who acquired the Tradescants' collection and bequeathed it to the University of Oxford.

Oxford's Ashmolean Museum (or Ashmolean Museum of Art and Archaeology) is the world's first university museum. Its first building, in Broad Street (on left), was erected in 1678–83 to house the Tradescants' cabinet of curiosities gifted to the University of Oxford by Elias Ashmole. The museum relocated to its current building on Beaumont Street in 1894.

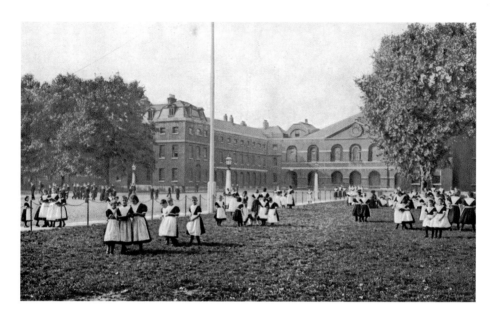

in the world. It remains in the heart of Oxford, now housed in a stately Victorian neo-classical building. The 'Old Ashmolean' still stands, home to the Museum of the History of Science.

With Britain's first museums open to the public, it was to be another half-century before the establishment of the first public art gallery, a distinction accorded to the Foundling Hospital, founded in 1739. Likewise a product of unusual circumstances, the hospital was set up by retired shipwright and businessman Thomas Coram (c. 1668–1751) to care for the numerous infants abandoned on the streets of London, for whom, in a time of soaring child mortality, the outlook was particularly bleak. Following Coram's death the task of fundraising passed to governors, including the artist William Hogarth and the composer George Frederick Handel, who used their skills and contacts in the arts to generate income and support. Handel conducted benefit concerts, including performances of his *Messiah*, while Hogarth persuaded his peers, including Thomas Gainsborough, Joshua Reynolds, Edward Haytley and

The Foundling Hospital, established by Thomas Coram in 1739 for the care of young children abandoned on the streets of London. Fundraising efforts undertaken by the first governors, including painter William Hogarth, led to the collection, creation and display of works of art, making the hospital in effect London's first public art gallery.

Captain Thomas Coram (c. 1668 –1751), the philanthropist who established London's Foundling Hospital.

15

Richard Wilson, to donate paintings and sculptures or join him in painting biblical scenes featuring different aspects of the foundling theme. Hogarth's vision of creating a collection of contemporary British art at the hospital paid off, and in 1757 the hospital governors decided to create a designated 'picture room' to best display and preserve the hospital's art collection. This became a much-visited destination for art connoisseurs, who were encouraged to donate to the charity.

Meanwhile, one of the founding governors of the hospital, Irish physician, naturalist and collector, Sir Hans Sloane (1660–1753) had elected to bequeath his collection to the nation on his death. By this time private collections or 'cabinets' had ceased to be the preserve of princes and the aristocracy, and had become relatively common among scholars and the more well to do. One influence of the Enlightenment had been to encourage a more methodical way of thinking, reflected in a more specialised form of collecting, moving away from cabinets of curiosity and towards a more logical, scientific approach. To this extent Sloane was a man of his time: one of the last of the so-called universal collectors, he spanned the traditions of old and new, collecting widely but using his collections in scientific work, such as his two-volume *Natural History of Jamaica* (1707), the result of his travels while physician to the West Indies fleet. Subsequently, Sloane held numerous offices and distinctions including Isaac Newton's successor as president of the Royal Society and doctor to Queen Anne, George I and George II. Also a shrewd investor, in 1712 he purchased the manor of Chelsea – where Sloane Square is named after him – as well as numerous ready-made collections. On his death in 1753, his books, manuscripts, prints, drawings, specimens, coins and more were left to his employer George II for the nation, provided parliament were willing to pay £20,000. The terms were accepted and the British Museum Act established Britain's first national museum based on Sloane's collection of 71,000 items along with George II's royal library, assembled by various monarchs. The new British Museum also benefitted from two other collections: the libraries of seventeenth-century antiquary Sir Robert Cotton, including the Lindisfarne Gospels and the Magna Carta, and the Harleian library created by the earls of Oxford, Robert and Edward Harley. Six years later the British Museum – a 'universal museum' intended to collect everything – was opened free of charge to the public in a Bloomsbury

Opposite and below: The British Museum has been through many changes since its establishment in 1753, most recently with the removal of the British Library to a new site in the 1990s and the construction of the largest covered square in Europe, the Queen Elizabeth II Great Court.

mansion, Montagu House. With this Britain had a national library and national museum in one, an institution to represent the nation and what it stood for. Unfortunately to modern eyes this is not without its difficulties and British acquisition of foreign treasures through imperialism and

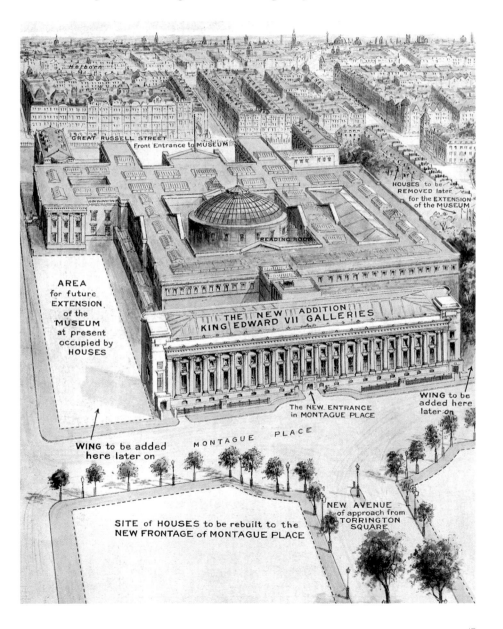

Whose heritage? The Elgin Marbles are a collection of classical Greek marble sculptures from the Parthenon in Athens. Originally removed by the seventh earl of Elgin, Thomas Bruce, the marbles were purchased by the British government in 1816 and placed on display in the British Museum. A classic example of plundered artefact, controversy continues about whether they should be returned to Greece or remain in the UK. Arguably more than any other objects, the Elgin Marbles highlight the complex and sometimes problematic nature of museums and the 'history' that they represent.

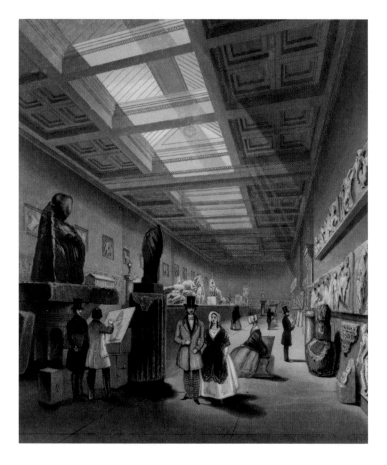

exploration – including most infamously the Rosetta Stone, key to deciphering Egyptian heiroglyphs, and the Elgin Marbles from Ancient Greek temple, the Parthenon at the Acropolis – have caused endless controversy. Even the initial intention that the museum would be for 'Public Use, to all Posterity' with access for 'all studious and curious Persons' also fell short as contemporary visitors complained of having to wait two weeks for a ticket and of being rushed around by uninterested guides.

With the British Museum open to the public, in principle at least, Scotland saw the establishment of a series of innovative museums and organisations of its own. First came the Society of Antiquities of Scotland, the oldest antiquarian society in Scotland, which from its foundation in 1780 began collecting archaeological and other finds. Soon afterwards the University of Aberdeen's Marischal Museum was founded in 1786 in Marischal College as a resource for display, research and teaching work.

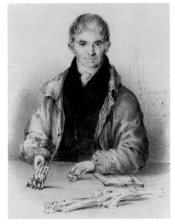

Far left: William Hunter (1718–83), Scottish anatomist, physician and ardent collector. Older brother of John, his collections formed the nucleus of the University of Glasgow's Hunterian Musuem and Art Gallery.

Left: John Hunter (1728–93), Scottish surgeon whose collections form the basis of the Hunterian Museum at the Royal College of Surgeons.

Similarly scholarly were the collections of the Lanarkshire Hunter brothers, William (1718–83) and John (1728–93). William, brilliant professor of anatomy at the Royal Academy and obstetrician and doctor-in-waiting to Queen Charlotte, used his fortune from work and investment to build a house with a lecture theatre, dissecting room and a museum to display his collection of anatomical and zoological specimens, coins, medals, books, manuscripts and paintings. These included artefacts from Captain Cook's South Sea voyage acquired fresh from the port and a Rembrandt, the *Entombment of Christ*, which he bought for a mere 12 guineas. While Hunter

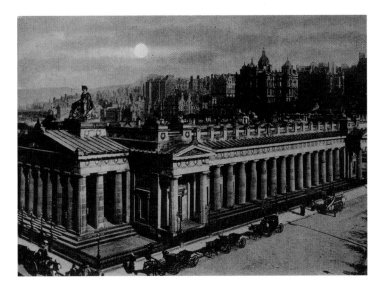

The National Museum of Antiquities, Edinburgh amalgamated with the Royal Scottish Museum in 1985 to create National Museums Scotland (renamed 2006). The buildings here were later remodelled and are now home to the Royal Scottish Academy and the National Gallery of Scotland.

The main exhibition hall at the Hunterian Museum of the Royal College of Surgeons, 1853.

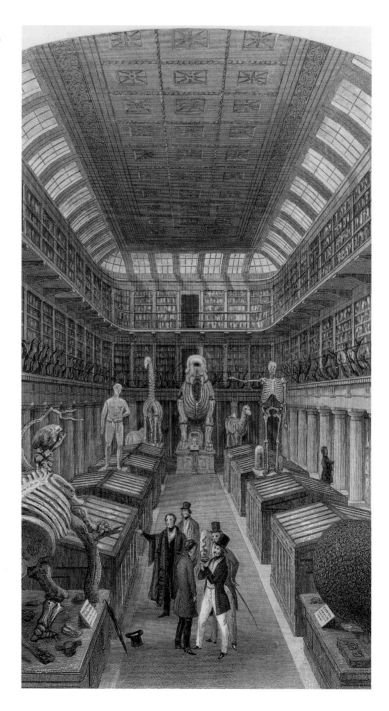

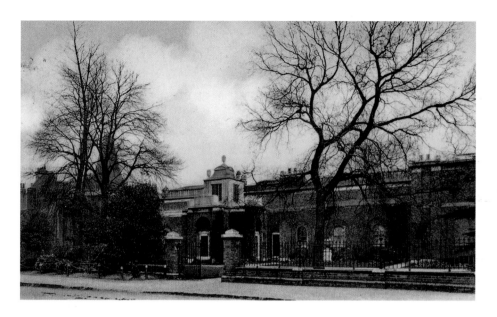

had wanted to build a museum in London, political procrastination had prevailed and his collection was eventually given to the University of Glasgow, where it became the nation's first Greek temple to art and science, open to the public as the Hunterian Museum in 1807. Meanwhile, his younger brother and competitor John, surgeon at St George's Hospital and to the king, founder of his own anatomy school and teacher and lifelong friend of vaccination pioneer Edward Jenner, had also amassed an extensive collection of animals and plants as well as medical specimens from his professional work. Originally a private museum in his Leicester Square home, the collection was primarily intended, unlike others of its time, to be used as a resource for teaching and demonstration and as an illustration of Hunter's ideas about species and adaption rather than a simple curiosity to behold. After his death, his executors persuaded the government to buy the important scientific collection for the nation and it was subsequently presented to the Company (later Royal College) of Surgeons, where it remains today in the London Hunterian Museum, Lincoln Inn's Fields.

Meanwhile in the world of art, the first specialised art museum had been established in 1764 in the Hermitage, St Petersburg to display the vast collections of Catherine the Great, although it was not open to the public. In 1793 the Louvre opened in post-revolutionary Paris, with treasures declared for the people. Also in the 1790s, two leading London-based art dealers, a Frenchman Noel Desenfans (1745–1807) and his friend Sir Peter Francis Lewis Bourgeois (1753–1811) were travelling across Europe

Dulwich Picture Gallery, designed by architect Sir John Soane and officially opened to the public in 1817.

21

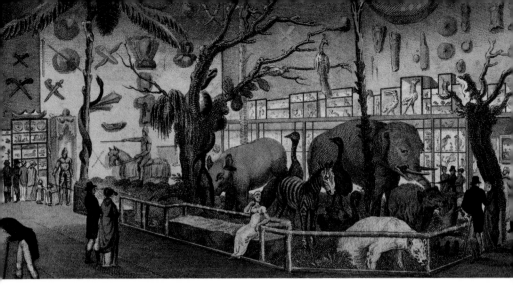

Bullock's Museum in Piccadilly. A museum and exhibition hall established by collector and entrepreneur William Bullock (1773–1849) where, for a shilling a ticket, visitors could see art, ethnographical and natural history collections, including curiosities brought back from the South Seas by Captain Cook. From 1812, exhibitions were housed in an extravagant Egyptian-influenced building, Egyptian Hall, where crowds swarmed to see objects of interest such as Napoleonic relics after the war with France. A popular attraction at a time when public museums were a rarity, the Hall passed through various hands before being demolished in 1905.

amassing an art collection for the king of Poland, Stanislaus Augustus, intended to form the basis of a national collection. However, the abdication of the king and subsequent partitioning of Poland meant that by 1795 the dealers were left with a collection to house. Political upheaval in Europe made the collection difficult to sell and it was initially kept in Desenfans' house, until on his death it was inherited first by his wife Margaret and subsequently by Bourgeois, who himself died in 1811. The collection was bequeathed to Dulwich College in Bourgeois' will, which stipulated that a new gallery should be designed and built to display the collection for 'the inspection of the public', dedicating funds for the purpose. The will also stated that Desenfans' friend, well-known neoclassical architect of the Bank of England, Sir John Soane, should be commissioned to undertake the work, the nation's first purpose-built art gallery. The site opened to the general public in 1817, featuring innovative top-lit galleries, almshouses and even a mausoleum for the bodies of Desenfans and Bourgeois.

Britain still lacked a national collection of its own, however, a point that had been noted by Desenfans and Bourgeois who had earlier offered their ready-made collection for sale to the government without success. Nevertheless efforts were already under way to resolve the issue and create a national gallery for art. While the late eighteenth century had seen the nationalisation of many royal collections on the continent, the same did not occur in Britain with the royal family retaining ownership of their collections until the present day. Despite repeated calls for a national art museum and several failures to acquire collections on the part of the government, it was not until 1823 when Russian émigré banker John Julius Angerstein's collection came on to the market that appeals were met and the government agreed to purchase the collection for £57,000, using Austria's unexpected

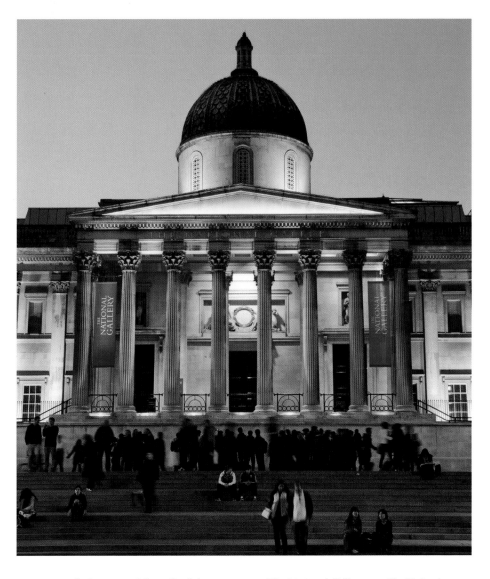

repayment of a large war debt to fund the transaction. The National Gallery subsequently opened to the public in May 1824, in Angerstein's former home at 100 Pall Mall. Apart from a short spell at number 105, it was to remain here until 1834, when the collection, now featuring numerous other acquisitions, was moved to a more suitable home, a palatial William Wilkins' building in the new Trafalgar Square, where it could be accessed by both wealthy and poor alike.

The National Gallery, established in 1824, found its third and permanent home on Trafalgar Square in the 1830s, in a new building designed by William Wilkins.

23

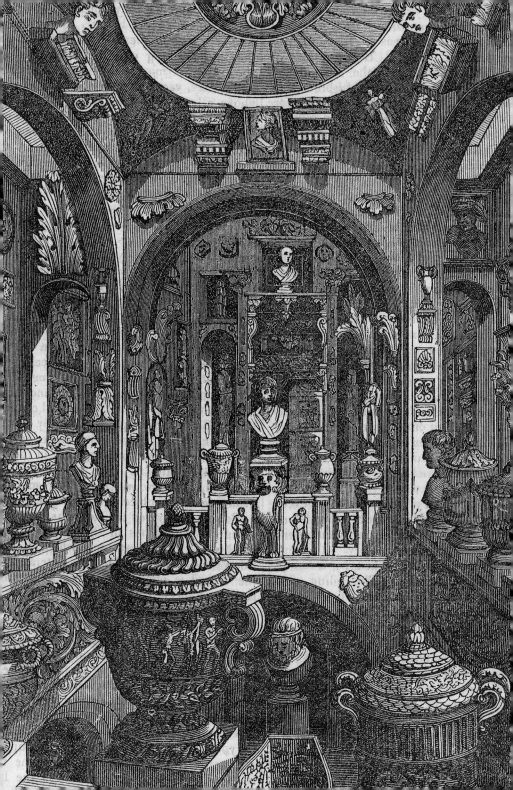

MUSEUMS FOR THE MASSES

B Y THE TIME OF Queen Victoria's accession to the throne, the principle of the public museum was well established in Britain and abroad. While many of these were iconic national institutions in landmark buildings from the British Museum to the Louvre, in London architect, professor of architecture at the Royal Academy, John Soane (1753–1837), chose to establish a public museum in his Holborn home. Architect of the Bank of England and Dulwich Picture Gallery, and leading light in his professional field, by 1824 he owned three houses: his original home at number 12 Lincoln's Inn Fields, and two neighbouring houses, numbers 13 and 14. Here, opposite the new Royal College of Surgeons and Hunterian Museum, he set about creating a spectacular display of art and objects, meticulously designed to evoke a sense of wonder and educate and inspire 'Amateurs and Students in Painting, Architecture and Sculpture' and others with interests and aspirations in the arts. From 1815, visitors – admitted strictly by appointment – were greeted by an exquisite collection of plaster casts and stained glass, sculpture, books and architectural models as well as a vaulted crypt inspired by the Roman catacombs. In addition visitors could enjoy an Oriental alabaster sarcophagus or the tomb of an Egyptian pharaoh, Seti I, and a picture room with an ingenious system of hinged panels which opened out over one another to display Hogarth's series *The Rake's Progress* and *An Election* among other works. By 1833, anxious that his collection would be dispersed after his death, Soane initiated an Act of Parliament to establish his house as a museum to be kept 'as nearly as possible in the state in which he shall leave it' and gifted to the nation after he was gone. The move was controversial; radical Tory demagogue William Cobbett opposed the bill on the grounds that 'it is morally wrong for a man to divert his estate from his family', while Sir Robert Peel believed the collection should be donated to the British Museum rather than becoming a separate financial burden on the nation. Indeed the year after his death, family members tried to claim ownership of the museum and its contents but failed in their attempt –

Opposite:
The cornucopia of exhibits in Sir John Soane's museum, as shown in this 1837 edition of popular weekly *The Penny Magazine*, has remained largely unchanged since his death.

25

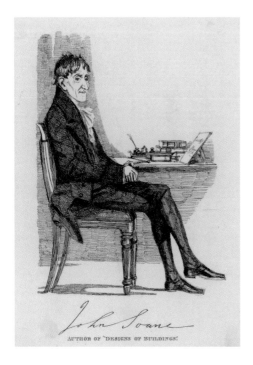

AUTHOR OF "DESIGNS OF BUILDINGS."

Neo-classical architect, Sir John Soane (1753–1837), who opened his London home as a museum and later gifted it to the nation.

meaning that they were kept for posterity as they had been left.

Less than two decades later, however, the British state took charge of the direction of museum provision in the country, a direct result of the success of the Great Exhibition of 1851. Symbol of progress for many, epitome of Victorian flaws for a few, the event in the Crystal Palace in London's Hyde Park was a runaway success, generating a profit of £186,000 and a dilemma about how best to spend the unexpected windfall. Following long-running debate and the intervention of Prince Albert, a devotee of science, education and the arts, the money was combined with a £150,000 government grant to purchase 87 acres of land south of Hyde Park in the village of Brompton. Here an extensive educational estate nicknamed 'Albertopolis' was planned, home to colleges, museums and learned societies. In the early stages, Sir Henry Cole, dynamic secretary of the Department of Science and Art, decided that the name of Brompton was dull and uninspiring and pushed for it to be altered to something with more appeal: and so the museum district of 'South Kensington' was born. By 1855, work had commenced on the first initiative, the South Kensington Museum, a temporary structure of iron and glass sited on the Brompton Road, set up to house miscellaneous collections from different locations, including those acquired from the Great Exhibition itself. While the so-called 'Iron Museum' was the cutting edge of Victorian prefabrication technology seen at the Crystal Palace, railway stations and piers, the museum was lambasted in the press as the 'Brompton Boilers' for its 'frightful ugliness'. The utilitarian structure may have been portrayed as a national disgrace but it brought together under one roof for the first time a vast number of science, industrial and art collections including those of the Commissioners of Patents' Museum, the Museums of Ornamental Art, the Architectural Museum, the general Trade Museum and the Gallery of British Art as well as items from the Great Exhibition formerly housed at the Museum of Manufactures at Marlborough House, subsequently moved to Somerset House on the Strand. The South Kensington Museum opened in June 1857, with Sir Henry Cole as its first director, receiving 14,000 visitors in its first week, while work commenced on a permanent building. Such was its continuing

popularity that a decade later weekly visitors still numbered some 10,000, encouraged by free entry for the public on Mondays, Tuesdays and Saturdays, and over Christmas and Easter weeks, together with late-night opening from 1858 (made possible through use of a new innovation – gas lighting). This all formed part of a deliberate attempt to discover what hours were most convenient to the working classes, essential if the collections of applied art and science were to be used as educational resources

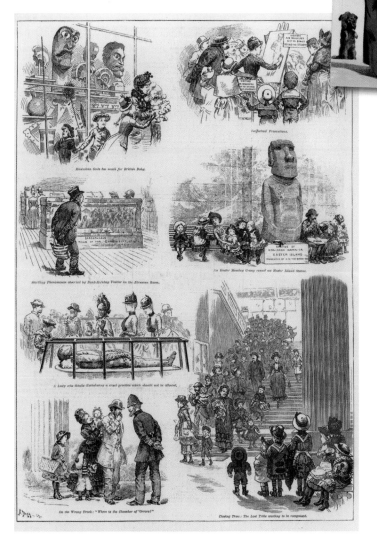

Sir Henry Cole (1808–82), civil servant and first general superintendent of the Department of Practical Art, was instrumental in the development of London's cultural quarter, South Kensington. Reflecting his status, here he is depicted as 'King Cole' in *Vanity Fair*'s long-running 'Men of the Day' series.

The meeting of cultures and of social classes in Victorian public museums provided rich material for commentators and cartoonists, as in these scenes from the British Museum published in *The Illustrated London News*.

to help boost productive industry for the nation, a key aim of the main players of 1851.

Developments at South Kensington were mirrored across Britain by a network of municipal museums, an outgrowth of more fundamental developments such as industrialisation, education and the rise of the Victorian city and town. Through the nineteenth century, a rapidly expanding population had deserted the countryside in search of work and opportunity in the growing number of factories and mills, spurring urbanisation on a massive scale. Around the nation, suburban streets, railway stations and shopping arcades were being built to provide for the growing populace, although the needs of the people were not merely physical. Literacy rates had increased sharply through the century, as a culture of self-help and self-improvement encouraged working-class artisans and others to educate themselves at local mechanics' institutes as well as through the surge of cheap books, pamphlets, newspapers and tracts that had resulted from the introduction of improved printing technologies and reductions in tax in previous decades. From the eighteenth century onwards a growing number of literary, philosophical and natural history societies provided an important intellectual outlet for the middle classes and proved a precursor to museums in opening membership libraries and putting on displays. Meanwhile, for all but the very poorest, Sunday schools, church schools, private schools and dame schools run by local ladies, as well as factories, workhouses and charitable systems, provided some semblance of education, however haphazard. By 1870, developments were enshrined in law by the Education Act, which finally introduced compulsory elementary education for all, although actual attendance remained far from total. The connection between education and museum development was becoming still more explicit in the growth and development of a number of museums owned and managed by universities. Higher education institutions had always collected objects and specimens for use in research and teaching, with many collections or buildings having their roots in bequests from individual enthusiasts and collectors or even, in the case of Manchester Museum, the collections of an energetic and far-sighted local natural history society. From the library and art collection of the seventh Viscount FitzWilliam which formed the basis of Cambridge University's Fitzwilliam Museum (1816), to the cornucopia of ornaments, carvings, weapons and shrunken heads collected by archaeologist and ethnologist Augustus Pitt Rivers and housed in Oxford's Pitt Rivers Museum (1886), such institutions continued to expand, while allowing (sometimes limited) public access to collections and displays.

Over time, the drive towards public education was matched by reduced working hours and shifting patterns of entertainment, transport and leisure, with the possibility of day trips and exhibition visits now firmly established

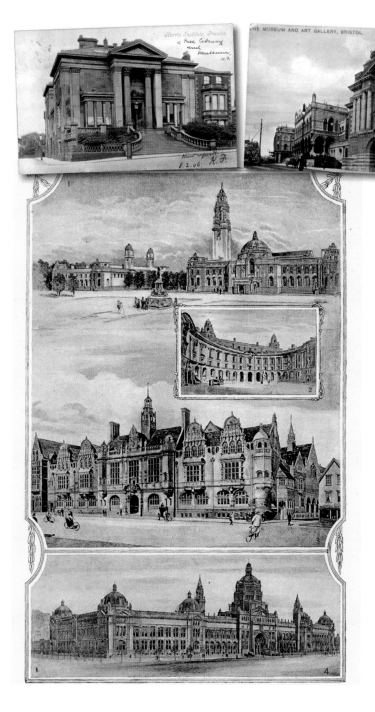

The Victorian craze for museum building was part of the wider trend for urban development and civic pride, reflected in buildings such as the Museum and Art Gallery, Bristol (above); Preston's Harris Museum (1880), named for local lawyer and benefactor, Edmund Robert Harris (above left); and left from top: Cardiff Town Hall and Law Courts, Government offices in Westminster, Oxford City Buildings and the Victoria and Albert Museum.

Liberal MP, William Ewart (1798–1869), who carried a bill for establishing free libraries and rate-supported museums, as well as the abolition of hanging in chains and capital punishment for cattle stealing and other relatively petty offences.

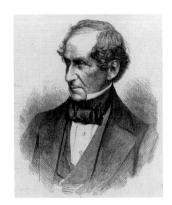

It was not uncommon for wealthy Victorian collectors to donate objects or even finance the building of a new museum or gallery in their name. One such venue – the Horniman Museum founded by tea trader Frederick John Horniman – opened in Forest Hill, south London in 1901.

in the popular mind. Across the nation, local authorities kept pace with the rapid rate of progress, with initiatives from sanitation systems and town halls to tramlines and new museums, lasting symbols of municipal pride. Their hand had been strengthened by legislation, such as the Museums Act 1845 which enabled town councils to found and maintain museums and Liberal MP William Ewart's subsequent Act of 1850, which permitted boroughs with a population of 10,000 or more to levy a rate of ½d in the pound to fund the establishment of a local museum on the condition that entry was free for all. Further amendments followed in 1855, 1866, 1868 and 1885, crowned by the Museums and Gymnasiums Act of 1891, which allowed the provision and maintenance of museums for the reception of local antiquities and other objects of interest, sanctioning a 2d rate on local residents for this purpose. Flagship cultural institutions such as museums were understandably attractive under such circumstances and town, parish, borough and city councils went to some lengths to ensure that their communities were represented in this way. By the 1880s, there

were already forty-five rate-supported municipal museums in England, supported by local rates and free entry.

Further momentum to the museum movement, and indeed free entry, was provided by sweeping concerns about the condition of the working classes, and more pertinently social control. In this light, museums were seen as a form of 'rational recreation', a civilising influence and a meaningful distraction from less respectable pursuits such as the music hall and the pub. The idea of donating money or collections towards the establishment of a museum or gallery therefore had a particular appeal to potential benefactors and middle-class elites, and this was a notable phenomenon in a period where voluntary and other charitable institutions had a significant role, spurred by religious zeal and social conscience. It is no accident that many Victorian institutions have their origins in sometimes startling incidents of individual generosity: from a donation of curios from local collector, Horatio Bland, that became the first holdings of Reading Museum, to Sir Andrew Barclay Walker's gift to the Corporation of Liverpool, the Walker Art Gallery. More famous still were two London art establishments dating from 1897: the Tate Gallery (now Tate Britain), the elegant brainchild of sugar magnate and art collector, Sir Henry Tate, and the vast private collection inherited by Sir Richard Wallace, known as the Wallace Collection, displayed from 1900 in Marylebone's Hertford House.

Whether backed by private donation, public subscription or local rates, a museum therefore became a vital feature of civic culture in every self-respecting city and town. While palatial, classically inspired buildings were striking symbols of local prosperity, collecting art and objects for the citizenry almost became a municipal responsibility, particularly in Manchester, Birmingham, Sheffield, Liverpool and other industrial centres. Civic museums varied but the vast majority focused on aspects of local history and collections bought or donated by local people, with popular subjects including fine arts, archaeology, geology, antiquities, anthropology and ethnology, military and natural history, numismatics, philately and botanical collections. As a result of such developments, by the 1880s Britain was experiencing a museum boom, with the number of institutions rising from ninety in 1860 to 217 (excluding national museums) in 1887, and 530 (including national museums) in 1928.

The Tate Gallery, renamed Tate Britain in 2000, was built on the site of the former Millbank Prison in Pimlico, financed by sugar magnate and art collector, Sir Henry Tate (1819–99).

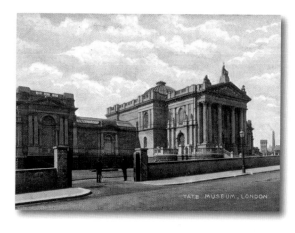

The nucleus of national transformation remained 'Albertopolis', where the Iron Museum had been dismantled in 1864–5, by then replaced by a permanent building. The original idea was that the iron structure could be split into three and sent to outlying boroughs at a nominal sum to assist in the establishment of smaller district museums. The offer was eventually only taken up by the East London Museum and Library Working Men's Association, which had petitioned parliament for a museum to serve the educational needs of the people of the East End. The building was therefore moved 8 miles east to Bethnal Green, to part of the green itself purchased by subscription by local residents. Here the government paid for the structure to be reconstructed – complete with a red brick exterior and mosaic murals replacing the corrugated iron walls and a marble floor made by female inmates in Woking Prison. When the museum opened in June 1872, the collections were similarly mixed. Despite initial suggestions that the new museum would be the local people's museum, filled with displays that they wanted, in reality it became an out-station of South Kensington stocked with objects no longer required in the main museum together with various miscellaneous collections. In the early years this included anthropological objects amassed by Colonel Lane-Fox, paintings owned

National museum in a historic house. The Wallace Collection of fine and decorative arts has been open to visitors to London's Hertford House since 1900.

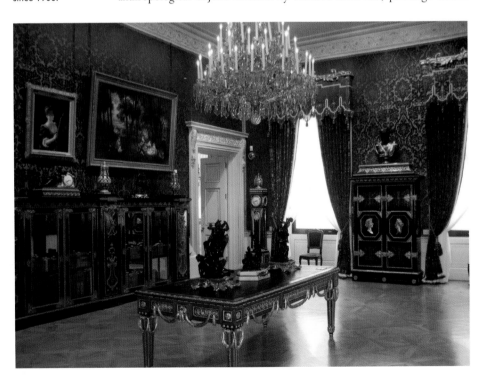

by Sir Richard Wallace, loans from the Dulwich Picture Gallery, and a food museum transferred from South Kensington that taught visitors about animal products and the nature and composition of food although exhibits were sometimes prone to decomposition according to contemporary reports. Opening hours and entrance fees were more appealing however, with free admission on Mondays, Tuesdays and Saturdays, matched by late opening until 10 in the evening. By the 1920s, the focus of the collections had famously shifted to childhood, with the museum finally becoming known as the Bethnal Green Museum of Childhood in 1974.

The V&A Museum of Childhood, formerly Bethnal Green Museum, was built around the iron frame of the original South Kensington museum, the 'Brompton Boilers', dismantled and transported to London's East End. It was opened by the Prince of Wales in 1872.

Back at South Kensington, ambitious plans for a district of cultural and academic institutions had continued with the building of a number of institutions including the Royal Albert Hall, Royal College of Music, The Royal College of Art, the Royal Geographical Society and Imperial College

The Victoria and Albert Museum under construction, early twentieth century.

of Science and Technology. In 1899 Queen Victoria laid the foundation stone of the Victoria and Albert Museum (V&A), now the world's largest museum of decorative arts and design but also home to science and industrial collections until the opening of the Science Museum in 1928. Meanwhile on the corner of Exhibition Road (named after the Great Exhibition), another new museum building, the British Museum (Natural History), had finally been opened in a distinctive Alfred Waterhouse-designed building in 1881, following many debates and delays. A driving force behind the establishment of the museum was controversial biologist, comparative anatomist and palaeontologist, Richard Owen, who as superintendent of the British Museum's Natural History departments had become convinced that the museum no longer had sufficient space for his collections to be adequately stored, conserved and displayed, and that the specimens and the visitors that came to see them were suffering as a result. In particular Owen believed that as much of the collections as possible should be displayed for the

Imposing façade of the Alfred Waterhouse-designed Natural History Museum – until 1992 the British Museum (Natural History) – equally notable for its extensive collections and displays.

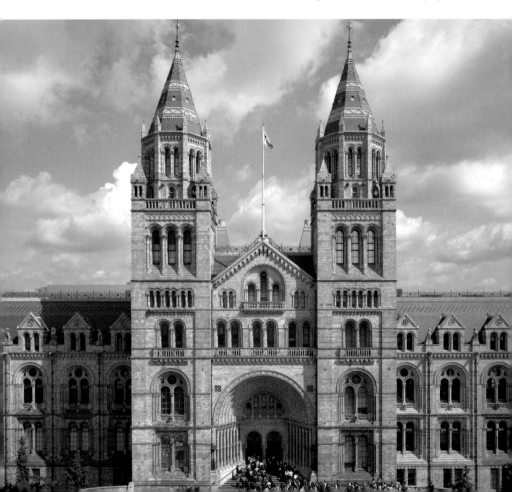

public to see, with species placed in their related groups, especially typical specimens with prominent qualities. Owen's subsequent retirement in 1883, and a new generation of staff, most notably the museum's first director, and one-time conservator at London's Hunterian Museum, William Henry Flower, heralded a series of changes that were to have a fundamental effect on way that museums in Britain were run. Heavily influenced by Dr John Gray, former keeper of zoology at the British Museum and critic of Richard Owen, by the 1890s, Flower was the leading proponent of what he called the 'New Museum Idea'. In contrast to the traditional approach of putting entire collections on show, ignoring the distinction between the needs of men of science and the more limited understanding of ordinary visitors, Flower publicly challenged the whole idea of what museums were for. The keynote of museum reform, he argued, should be the differentiation between popular and professional audiences: museums were not merely about displaying things, the interpretation of collections for varied audiences was paramount, also involving the imagination and inventiveness of curators and other staff. In his 1893 address to the British Association for the Advancement of Science and his subsequent *Essay on Museums* (1898), Flower asserted that in many respects museums were like living organisms, requiring continual and tender care. Following Gray, he contended that museums had two main purposes: 'the diffusion of instruction and rational amusement among the mass

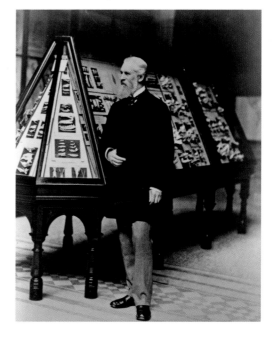

Sir William Henry Flower (1831–99), comparative anatomist, surgeon and director of the Natural History Museum.

of the people' and also 'afford[ing] the scientific student every possible means of examining and studying the specimens of which the museum consists'. To achieve the two-fold aim of education and recreation, he believed careful attention must be paid to the proper management and display of collections and exhibits, and the lighting, comfort and ventilation of the galleries, with special arrangements for those who wanted to undertake in depth study. This 'new museum idea', first propounded in Britain by Gray and widely publicised by Flower, was to gradually transform museum practice from a tendency towards overcrowded displays of uninterpreted curios to a focus on organisation for the public good, as places of instruction and amusement for the whole community.

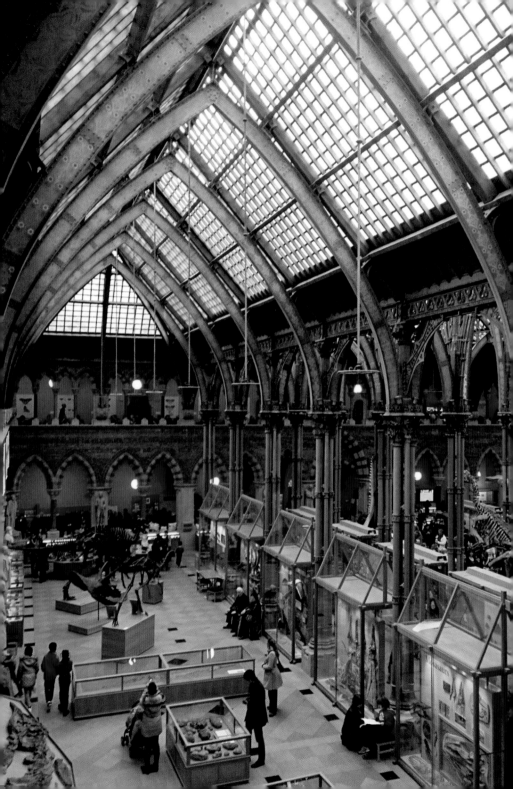

OPENING THE DOORS

FUNDAMENTAL to the development of museums in Britain is the idea that they are a reflection of the cultures, and at points classes, that create and curate them. From what was collected to how it was exhibited, Victorian museums large and small were an integral part of wider assumptions about culture and control. From objects appropriated in the furthest reaches of empire to concerns with regional identity and national pride, museums illustrated ideas about order and progress, ownership and control, particularly in light of evolutionary thinking popularised through the latter part of the nineteenth century. While that period saw museums achieve a recognised place in national life, progressing from treasure troves to potentially active forces in local communities, displays tended to portray a clear and uncomplicated ordering of history – with ample interpretation of Britain's leading role – for the benefit of middle-class audiences. While such themes continued through the twentieth century, the period was undoubtedly dominated by increasing systemisation and specialisation, both in types of institution open to the public and in the practice and perception of their work.

Central to this were changing notions about the role of the museum, particularly evident through developments in education and display in common with William Henry Flower's 'New Museum Idea' for natural history institutions. Although management of collections remained paramount, museums increasingly sought to open their doors to the public, providing new spaces from lecture halls to auditoriums, new wings and extensions accompanied by more proactive, pre-planned educational programmes of activities and events. Chamber music, organ recitals and even theatrical productions became more commonplace and local societies and interest groups, from art to natural history, were encouraged to use museum collections and facilities in their work. Beyond the museum, curators sent out lecturers and loan collections, and organised excursions to local sites of interest where people could study topics in context, and even

Opposite: From the time of the Ashmolean Museum, established by Oxford University, universities have played a vital role in the safeguarding and display of collections. Oxford University Museum of Natural History cares for many of the institution's natural history specimens.

participate in collecting and excavating work. Classes of elementary-school children were welcomed to larger museums as a matter of rote – in an average week in the early 1950s, staff at Manchester Corporation Art Gallery would accommodate some five hundred schoolchildren while the university-managed Manchester Museum played host to one hundred elementary school classes; special opening hours for visits from children and young people were standard at many institutions from the late nineteenth century.

Palaces of lifelong learning. In this photograph from the 1940s, a schoolgirl uses the collections at the Geffrye Museum of historic interiors in her studies.

This desire to educate and engage audiences also extended to the treatment of collections and displays. Through the first half of the twentieth century, changing exhibitions became customary, both through use of a museum's own collections and exploitation of loan material that was circulated nationally. The way in which objects were displayed also went through transformation, with greater attention paid to historical context and understanding of simply displayed material, rather than relying on the assumption that visitors were in some way subject specialists who would have the ability to interpret large collections of curios for themselves. More advanced institutions, such as the Victoria and Albert Museum, had already started to circumvent the tendency to arrange material according to artistic movements or countries, and establish 'period rooms' – utilising original woodwork from historic buildings or reproduction backdrops to provide settings for furniture, paintings and other objects. Likewise many art museums rethought the display of their picture collections, away from works hung in tiers according to size, shape and colour, designed to decorate a palatial space, and towards new techniques such as the hanging in one room, in comparative isolation, of a few selected works. On a larger scale, the growth of collections, including modern works, was seen to necessitate new and separate galleries for their display, such as at the Tate Gallery in London (now Tate Britain), while the National Portrait Galleries of London (1856) and Edinburgh (1882) represented attempts to specialise in portraiture, by gathering many such works together in single venues.

The drive to specialise was not restricted merely to art galleries however, and increasing systemisation in curatorial practice was matched by the development of a number of distinct types of museum focusing on particular collections and themes. National and municipal museums were by now long established phenomena, with the British Museum and the National Museum

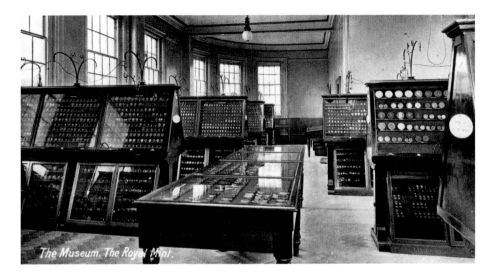

The Museum. The Royal Mint.

of Scotland joined finally by the Cardiff-based National Museum of Wales, formally opened by George V in 1927. Local museums were an established feature in most large towns, while university museums in places such as Oxford, Cambridge, Manchester and London had been largely but not solely an outgrowth of Victorian collecting zeal, the demands of academia and generous personal bequests. Through the twentieth century, the number of national museums continued to grow further, reaching a total of fifty-four across the UK in 2012.

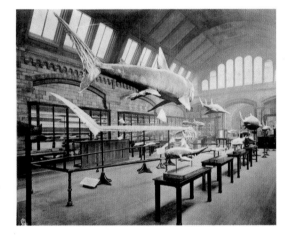

Meanwhile, the wider world of museums had become still more diverse with an array of new types of institution, their establishment driven by numerous factors, scientific, technological, economic, social and specialist – from the eccentric to the sublime. This includes a number of museums dedicated to the military and war: most famously, Imperial War Museums (IWM), a national museum organisation with five sites in England – warship HMS *Belfast*, historic airfield IWM Duxford, underground wartime command centre the Churchill War Rooms, Salford-based Imperial War Museum North and the original Imperial War Museum in London. The latter was established in 1917 to record the civil and military war effort and

Museums are still closely associated with old-fashioned glass cases and displays, seen here at the Royal Mint Museum and in the shark room at the Natural History Museum.

sacrifice of Britain and its empire during the First World War, although its remit now covers all conflicts involving British and Commonwealth forces since 1914. Integral to its role is the challenge of interpreting difficult subject matter (sometimes known as 'hot interpretation') from the Holocaust to recent politically contentious conflicts such as the Iraq War, a task backed by an extensive sound archive and object, art, film, video, photograph and archival collections. Originally housed at the Crystal Palace at Sydenham Hill, the museum opened to the public in 1920; from 1936 it found a permanent home in the buildings of the Bethlem Royal Hospital, the Southwark institution for treatment of the insane. It survived bombing during the Blitz to become the leading public museum organisation for conflict and war. Likewise focused on the interprelation of war are the National Army Museum, established in 1960, and the Royal Naval Museum at Portsmouth dockyards, as well as by numerous smaller museums and museum galleries dedicated to – and often funded by – individual regiments. The continuing prevalence of military heritage across Britain demonstrates the fundamental need to understand and memorialise the struggles and human cost inherent in war, and arguably more than any other venue reminds us of the larger place of museums, and of history, in the rationalisation and remembrance of certain aspects of the past.

Beyond war, the twentieth century has seen the opening of museums on almost every conceivable topic – from lawnmowers, toys and fans to pencils, Bakelite, baked beans and witchcraft, no subject seems too quirky or obscure. Some of the most intriguing are small independent organisations originally based on the objects owned by a specialist or enthusiast with a desire to spread knowledge about their subject, in some cases people whose personal collections have become so large that creating a public museum has seemed more practical than trying to store and display items in their individual homes. One such example is Robert Opie, founder of London's Museum of Brands, Packaging and Advertising, whose collection of wrappings, tins, toiletries, posters and more began with a Munchies packet at Inverness station in 1963, which spurred his lifelong fascination with brands and what other people consider rubbish. Following an exhibition of his collection 'The Pack Age: Wrapping It Up' at the Victoria and Albert Museum in 1975, Opie established a museum at Gloucester Docks in 1984, and later in London, where the

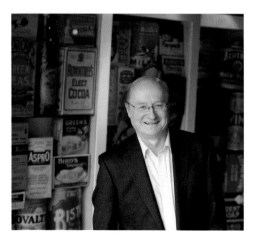

Inveterate collector and founder of London's Museum of Brands, Robert Opie.

public can see a range of exhibits and displays from Victorian ephemera to a 1980s peach melba Ski yoghurt carton. Together this material shows that 'rubbish' takes on a special resonance over time, affording an insight into the way we live, contemporary design and domesticity, as well as challenging ideas about what we collect and why, and what such material can tell us.

Also focused on how we live, on a grander scale, has been the twentieth-century trend towards folk-life and open-air sites. These had their roots in Scandinavia, where several museums featuring re-erected buildings from different places and periods were opened during the last quarter of the nineteenth century, most famously at Skansen in Stockholm. A reaction to industrialisation and its impact on rural lifestyles, folk-life and open-air museums sought to keep alive an understanding of how working – often rural – people lived, particularly through displays of re-erected vernacular architecture and demonstrations of practical, traditional crafts. The approach became popular, particularly in America where a reconstruction of the colonial capital of Virginia, Colonial Williamsburg, was opened in 1926 and Greenfield Village at Dearborn, the first open-air American site along Scandinavian lines, was founded by car manufacturer Henry Ford in 1929 (part of The Henry Ford). For the first British example, one must look to the Welsh Folk Museum at St Fagans, an outgrowth of the National Museum of Wales, opened twenty years later to the west of Cardiff. The site was a gift from the Earl of Plymouth, who offered St Fagan's Castle and the surrounding estate, now covering 100 acres of woodland and pastures, for the establishment of an open-air museum to tell the story of the people of Wales. Faced with the considerable challenge of capturing and interpreting national identity, the museum now plays home to more than forty original buildings, from a 1760 Powys woollen mill to a set of nineteenth-century ironworkers'

Retired Indian Army officer and amateur archaeologist, Colonel Frederick Hirst, pictured here at one of his digs at Porthmeor, Cornwall c. 1937. Hirst's aim was to establish a museum reflecting the history and lives of the people who lived and worked in the ancient Cornish landscape. Exhibits from his collection were originally displayed on the wayside in the Cornish village of Zennor for the benefit of passers-by. Today the Wayside Museum and Trewey Mill exhibits over five thousand artefacts alongside a fully working watermill producing organic flour.

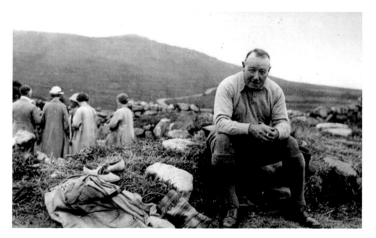

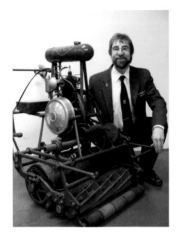
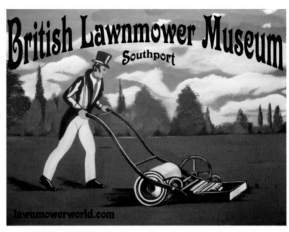

British museums cover a vast array of collections and specialisms, from pencils to types of plastic. Pictured here is Brian Radam, curator of the British Lawnmower Museum, with an Atco Standard.

houses from Merthyr Tydfil, besides the castle itself. The re-creation of a historic environment also extends to farming and land management; the museum maintains traditional breeds of livestock and cultivates historically accurate crops through use of traditional techniques.

The approach proved popular and folk and open-air museums proliferated in Britain through the 1960s and 1970s with sites such as the Ulster Folk and Transport Museum (1958–67), Avoncroft Museum of Buildings, Bromsgrove (1963), Ryedale Folk Museum (1964), the Weald and Downland Museum at Singleton, West Sussex (established 1967, opened 1971), the Museum of East Anglian Life (1967), the Chiltern Open Air Museum (1976) and the Black Country Living Museum (1978) among others. While trying to capture local history through reconstructed environments, these sites tend to specialise in regional craft, environment and trade, from local geology and historic building techniques at Weald and Downland to the 'into the thick' underground mine experience at the Black Country Living Museum.

These places have not merely been concerned with rescuing good examples of vernacular architecture and the idiosyncrasies of bygone agricultural life however; through this period there was a drive to develop industrial open-air museums in line with wider concern about the preservation of Britain's manufacturing past. By the late 1980s there were nearly five hundred museums featuring industrial content, approximately a third of which had been established since 1970. Two well-known sites best illustrate the trend: County Durham's Beamish museum and Blist's Hill Victorian Town in Ironbridge, Shropshire. The first of these, Beamish, opened to the public in 1972 with five staff on a 300-acre estate in the heart of the Durham coalfield. The result of a long campaign by Bowes Museum

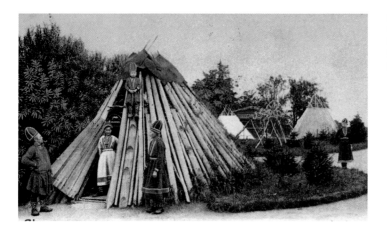

Inuit people and dwellings at Skansen, Sweden, the world's first open-air museum.

director Frank Atkinson, this was the first regional open-air museum, offering a depiction of a northern, industrial way of life that was rapidly disappearing with the demise of coalmining, shipbuilding and other heavy industry. The site features a collection of buildings re-sited from across the north-east, including Georgian houses from Gateshead, a pub from Bishop Auckland, a row of pit cottages from Hetton-le-Hole and a co-operative store from Anfield Plain, while the original site already included a farm and farmhouse, Pockerley Manor, a medieval defensive stronghouse, an eleventh-century manor house, Beamish Hall, and its own drift mine, closed only in 1962. Taken together the main collection (excluding Beamish Hall) represents a period from the 1790s to the 1930s, although interpretation focuses largely on two distinct periods – 1825, the year the Stockton and

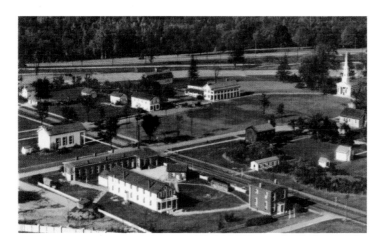

The Henry Ford (also known as the Henry Ford Museum and Greenfield Village) was the first open-air museum site in the United States, at Dearborn, Michigan.

43

From the mid-twentieth century Britain saw the establishment of a number of open-air museums based on collections of historic buildings, such as this Workmen's Institute at St Fagans National History Museum, Wales. The Institute was built in 1917 as a centre for social, educational and cultural activities in the mining community of Oakdale, Monmouthshire. It closed in 1987, and was later dismantled and re-erected at the museum for the benefit of visitors and educational groups.

Darlington railway opened, and 1913, the peak coal production year in the north-east.

Meanwhile in Shropshire, the future of a unique historic environment in the Severn Gorge had been the subject of deliberations by the Dawley (later Telford) New Town Corporation. Now branded 'the birthplace of industry', the site was a case of 'conservation through neglect' where lack of investment and redevelopment had led to the survival of numerous locations associated with the early iron, brick, tile and pottery industries. It was here that Quaker manufacturer Abraham Darby first smelted iron-ore from coke commercially; decades later, in 1779, the world's first iron bridge was built across the gorge by Abraham Darby III, and in 1802 Richard Trevithick's locally built steam locomotive was driven over it. By the end of the eighteenth century a quarter of Britain's iron was smelted at Ironbridge. New Town planning discussion led to the foundation of the Britain's largest independent museum charity, the Ironbridge Gorge Museum Trust in 1967, and subsequent creation of an open-air museum, Blist's Hill Victorian Town around Blist's Hill furnace and part of the old canal network and 'inclined plane' at Coalport (the tracks used to transport materials between the railway and the canal). Since 1973 the public have been able to explore re-erected historic buildings, ranging from a school to a squatter's cottage; watch demonstrations, including at the world's only wrought-iron works; and buy heritage-style items from costumed interpreters in the village shops using special Blist's Hill currency exchanged in a nearby bank.

This points to an important distinction between open-air and indoor museum sites: the use of 'living history' practices. The term 'living history' has become the catch-all name for a range of dramatic interpretative

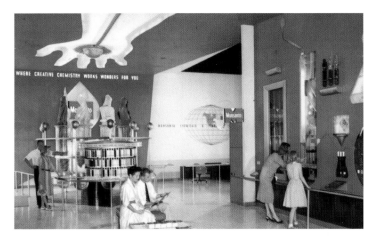

Epcot theme park, celebrating human achievement with interactive displays at Walt Disney World, Florida since 1982 (left), and historical re-creation Main Street, Disneyland (below). The Disney empire's impact on attractions is such that 'Disneyfication' has been widely employed to criticise the authenticity and educational worth of some styles of museum interpretation and display.

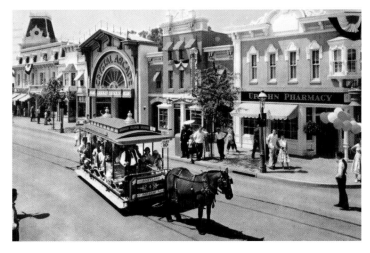

techniques, ranging from craft demonstrations and re-enactments by enthusiasts to costumed interpreters who talk to visitors as a character, speaking in the first or third person, even sometimes feigning ignorance of modern life as part of the pretence. While the earliest open-air museums tended to opt for textbook-style 'third-person' interpretation, the influence of theatre as well as an increasing emphasis on visitor enjoyment, emotional experience and novelty, led to the growth of 'living history' styles of presentation and some heated debate as a consequence. Most notably, critics have cast aspersions on the exploitation of dying industry for entertainment, tourism and profit and the Disneyfied image of history that open-air museums allegedly present.

While there is no doubt that open-air sites provide a selective and pleasant depiction of another time; re-creating the stenches and squalor, terror and pain of the past would undoubtedly transgress modern employment law and health and safety regulations, not to mention visitor expectations and demands. Authenticity and scholarship are often highly

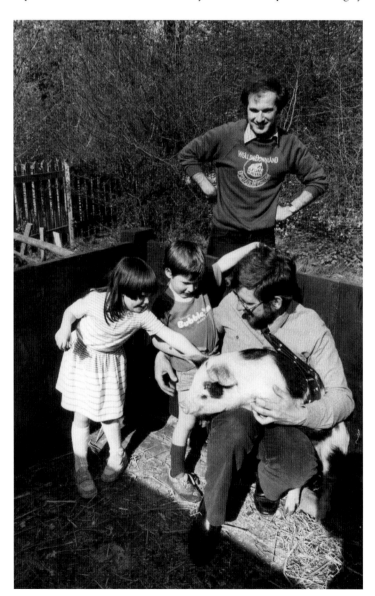

'Hands-on' learning at a living-history site. Children visit the first pigs at the Weald and Downland Open Air Museum – Berkshire x Gloucestershire Old Spots bred locally in Sussex – observed by future museum director, Richard Pailthorpe.

valued at open-air sites, which can mimic traditional museums in having large research archives and carefully checking provenance of objects on display. However such sites have in common an attempt to present a reconstruction as 'real' and provide a more immediate experience of the past for visitors. While 'bringing history to life' is a constant refrain, presentation is undoubtedly selective with emphasis placed on harmony and consensus at sites generally set in idyllic rural locations and rolling countryside. One issue here is the nostalgia effect: types of buildings or objects still in use have a direct appeal to the personal memory of visitors, which deepens their interest, empathy and emotional attachment to the past. Albeit seductive, this type of presentation can discourage critical engagement with and understanding of historical processes, while selling the idea that we can travel back in time. This is compounded by the fact that open-air museums are microcosms, artificial environments made up of buildings and artefacts from a number of different places and different times. As well as remembering, open-air museums can therefore cause visitors to forget: with divisions and misery side-stepped and heavy industry cleaned up, the format can serve to disguise the nuances and harsh realities of the very history that they claim to represent.

The popularity of open-air museums, with their broad emphasis on the living history of regions and communities, is mirrored by the enduring appeal of historic house museums, which focus more closely on the lives of the individuals and families who previously lived there. Predominately, though not always, based at the past residences of famous (and infamous) people, these buildings provide a way to tell the story of their subjects' lives and give a public glimpse into their private existence and daily routine. Their perpetual appeal is undoubtedly founded in a fascination with the minutiae of other people's lives and a desire to understand what makes people tick. More than anything they illustrate the charm of biography, and in keeping with this, the list of historic house subjects is long: writers and artists, poets and politicians, men of science and of discovery, even fictional characters such as Sherlock Holmes, have all had sites opened in their name. From birthplaces to deathbeds, historic house museums have been founded around numerous locations from townhouses and humble cottages to sprawling country retreats. Some, such as Victorian Arts and Crafts pioneer William Morris have more than one residence to their name (Red House and Kelmscott Manor), others such as former Beatle Sir Paul McCartney (Forthlin Road, Liverpool) have had childhood homes opened to the public while still alive. In keeping with this, the significance of place may vary greatly: the Charles Dickens Museum in Doughty Street, London only played home to the author for a short period, 1837–9, while others such as Charles Darwin's Kent home Downe House, and the Brontë Parsonage

From humble roots to hero history, modern museum environments can be found at a range of sites. This is the kitchen in Paul McCartney's childhood home, 20 Forthlin Road, Liverpool, which is now owned by the National Trust.

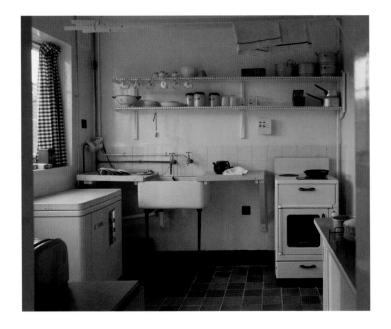

bordering the moors at Haworth were home for several decades and the scene of the bulk of the work for which their occupants are renowned. Scenes of profound events or 'eureka' moments of inspiration, creativity or invention, such as Newton's apple tree at Woolsthorpe Manor undoubtedly have a certain panache. The same may be said of homes which afford an insight into aspects of an individual's talent or professional life, such as designer Charles Rennie Mackintosh's townhouse, 78 Derngate, Northampton, or Victorian artist Frederick Leighton's richly decorated west London studio and home.

Considering the motivation to open such properties, the drive to present 'hero history' is strong. This can even extend to the opening of historic house museums belonging to less well-known albeit interesting relatives and friends. As one might expect, interpretation frequently tends towards the traditional, relying on room sets and stewards, audio tours, panels, leaflets and guides. Authenticity and atmosphere are understandably important, and the presence of original features and artefacts from the life of the subject holds greater interest and appeal than reproductions or period items shipped in. The temptation, evident at many historic house museums, is to create latter-day shrines to the property's illustrious former inhabitant, or to freeze a building at just one point in its long history.

In contrast, growing interest in 'history from below' has led to a trend in recent decades for opening up and interpreting the homes of the ordinary,

improvident and less well to do. Examples of this may be found in grocer Mr Straw's House in Worksop, Nottinghamshire, or Birmingham's last surviving court of back-to-back houses, both managed by conservation charity, the National Trust. The latter site presents each house as it would have appeared at a particular time between the 1840s and the 1970s, to educate visitors about change over time through comparison of the living conditions of ordinary people. Meanwhile, at country houses, in a reversal of the 'upstairs-downstairs' model, properties are sometimes presented from a servant's perspective or seek to provide an insight into servant life. At the Errdig estate in Wales, for example, visitors enter the property through the kitchens, while sites such as Oxfordshire's Chastleton illustrate the recent trend for 'time capsule' interpretation, striving to conserve a property as it was left, however unkempt.

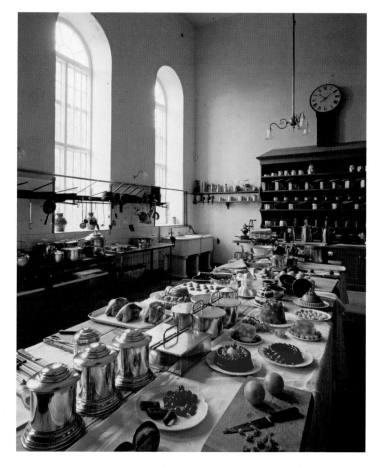

Upstairs, downstairs. Late seventeenth-century mansion, Petworth House, contains the National Trust's finest collection of pictures, sculpture, furniture and carvings counter-balanced by servants' quarters that are also open to the public.

EPILOGUE

DESPITE notable transformations through the twentieth century, museums still labour under a 'stuffed bird' image of fusty academia and dreary displays. Impressions aside, in recent years there has been an increasing diversification and blurring of boundaries between the 'traditional museum' and new initiatives – especially marked from the 1970s by the trend for heritage centres. Hybrids between traditional museums and visitor attractions, and in some ways the successor to folk-life and open-air sites, such centres tend to prioritise experience, entertainment and spectacle above more complex historical interpretation and broader educational aims. While a heritage centre may use methods of instruction that are quite similar to those found in museums – such as displays of objects – material tends to concentrate on one specific, simplified theme or story about the past. Complete with multimedia representations, heritage attractions such as York's Jorvik Viking Centre (1984) and Chocolate – York's Sweet Story (2012), run by visitor attraction company Continuum, have employed technology such as lighting effects, life-like mannequins, voice recordings and chemically produced 'smells of the time' in order to entertain visitors. The media and the experience on offer, and its all-important marketing appeal, tend to predominate over a critical presentation and evaluation of the past. While this concept is not entirely new, with its roots in waxwork models, panoramas and sideshows put on by circus impresario P. T. Barnum and others through the nineteenth century, such attempts to recreate reality have had some impact on traditional museum displays. Well-known examples are provided by the Imperial War Museum's 'Blitz Experience' (1989) and the 'Trench Experience' (1990), which use sight, sound, smell and even earth-shaking sensations, in an attempt to 'bring history to life' for its visitors.

As boundaries blur between education and entertainment, the engagement of all of the senses, particularly sight, hearing, smell and touch, is now considered best practice in museum interpretation and is utilised

Opposite: On the approach to its 250th anniversary the British Museum undertook a major redevelopment programme, made possible by the removal of the British Library to a new building at St Pancras. The British Museum project centred around Lord Norman Foster's Queen Elizabeth II Great Court, designed to serve as a striking civic space for the new millennium.

Heritage centres, such as York's famous Jorvik Viking Centre, have become increasingly popular over recent decades, blurring boundaries between education and entertainment and raising issues for conventional museums and their role.

Waxworks such as this domestic scene from the South Wales Miners' Museum at Afan Forest Park have long been used as a technique for recreating 'reality', with varying degrees of success.

in some form in all but the most basic or under-resourced of new museum displays. Meanwhile technology and 'hands-on' learning techniques have become all the more common, particularly in new museums and science and discovery centres. While science and natural history in particular have provided an age-old focus for collection and display, recent decades have seen the opening of a number of new ventures with emphasis firmly placed on learning in an interactive way. From innovations such as the Manchester's Museum of Science and Industry (1969) and the Science Museum's Launch Pad (1986), to ventures such as Jodrell Bank Visitor Centre in Cheshire (1971), national children's museum Eureka! (1992) and Techniquest in Cardiff (1986), new technology and hands-on activity and experimentation has been used to explain subjects ranging from pure and applied science to town planning and telecommunications. This trend, boosted by private investment, regeneration and cultural tourism agendas, has been mirrored by the development of maritime and waterside sites. While the National Maritime Museum had been established in Greenwich since 1934, heritage and water-themes centres proliferated from the 1970s in line with the regeneration of inner cities, docklands areas and the historic canal network. As with science

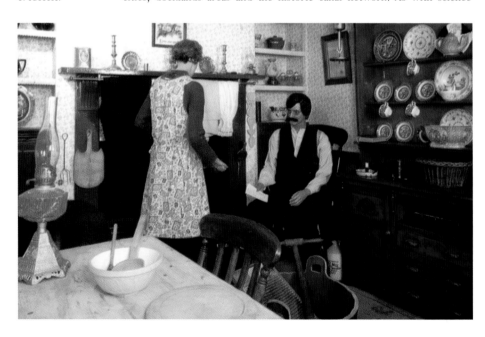

BARNUM'S MUSEUM
COR. BROADWAY & ANN ST., NEW YORK
Site of St. Paul Building
1841.

Sideshows have a long history in parallel with traditional museums, represented most notably by the work of American showman Phineas Taylor 'P.T.' Barnum and French wax sculptor, Marie Tussaud.

and discovery centres, these were seen to provide an important historic, leisure and tourism dimension to new and transformed developments, and maritime, industrial and science themes centres were – and remain – very much in vogue. Among many such sites are Chatham Historic Dockyard (1984); Liverpool's revitalised Albert Dock with its Tate Gallery (1988) and museum complex including a Maritime Museum (1980), World Museum (2005), International Slavery Museum (2007) and new Museum of Liverpool (2011); the Canal and River Trust museums at Gloucester Docks (1988) and Ellesmere Port. Also of note is the old royal dockyard at Portsmouth, now Portsmouth Historic Naval Dockyard, complete with Royal Naval Museum and warships, HMS *Victory*, HMS *Warrior* and Henry VIII's *Mary Rose*, sunk in the Solent in 1545, raised to the surface amid much media hype in 1982, and now complete with its own museum. In the dockyards of Belfast, the Titanic Experience (2012) forms the cornerstone of the Titanic Quarter, Europe's largest urban regeneration project. Meanwhile in towns and cities of the north, derelict land grants led to the establishment of Manchester Museum of Science and Industry (1983) on the old Castlefields station site, and of the Wigan Pier Experience (1986), focused on social and industrial

Lancashire life in the early twentieth century. More recently a National Football Museum opened in Preston in 2001, part of a wider regeneration and tourism agenda, intended to attract people to the town. Tellingly, concerns over funding and sustainability led to its relocation and reopening in Manchester in 2012.

Born of hard work and high ideals, new museums, heritage and science centres are also notoriously high-risk endeavours, and never more so than around the year 2000, when a multitude of new sites were established to mark the start of a new millennium. As ever, memorialising the past and local identity was seen as a fitting way to leave a legacy and many large capital and cultural projects emerged as a result. Iconic design and digital forms of interpretation and learning abounded in line with technological developments and a futuristic new Millennium feel. However, as the nation's £789 million flagship project – the Millennium Dome (2000) – illustrated, sustainability is a constant concern, with Sheffield's National Centre for Popular Music (1999) closing in just under a year, followed by Doncaster's Earth Centre in 2004. More successfully, Newcastle gained a science centre, the International Centre for Life in 2000, while Birmingham saw the opening of Thinktank (2001), now firmly established. Meanwhile, the old dockyards on the Manchester Ship Canal at Salford were transformed into Salford Quays, home to the Lowry (2000), a gallery dedicated to the work of local artist L. S. Lowry built at a cost of £70 million, followed by its impressive neighbour, the Imperial War Museum North (2002). In London, the Tate Modern opened on the South Bank and the British Museum

Heritage and waterside sites have become closely linked with the regeneration of inner cities and abandoned industrial areas of the past. This can be seen at places such as Liverpool's Albert Dock and Gloucester's old wharfs, warehouses and docks, now home to Gloucester Waterways Museum, run by the Canal and River Trust.

opened a major extension, the covered Queen Elizabeth II Great Court, in Millennium year. In an uncertain climate, with increasing competition among numerous venues and for leisure time generally, a strong exhibitions programme, clever marketing and an effective brand remain key.

Alongside new venues came other important developments for the sector: free admission to national museums was introduced in Scotland, Wales and then England in 2001, while the 'Renaissance in the Regions' programme of 2002 pledged £300 million of central government funds over nearly a decade to transform English regional museums. Sustainability still looms large and the dreary perception of museums sometimes remains – at the extreme, the 50-acre open-air Museum of Kent Life, now managed by Continuum, has recently been rebranded, removing 'museum' from its title so as not to deter potential visitors.

Behind the rhetoric, even traditional sites are constantly re-evaluating the role of the museum, leading to new and ever-evolving approaches to interpretation and learning. Much was made possible by the 1972 Local Government Act which allowed for rate-funded museums to be run by both district and county councils, which enabled the creation of comprehensive local authority museum services with centralised programmes of education, exhibitions and conservation work. Much current thinking is founded on the idea of access and 'audience development' as museums search for interesting ways to engage visitors – both existing and potential – in various aspects of their work. Backed by a 'social inclusion' agenda, it is now common practice to work with overlooked or 'hard to reach' community groups whether they be young or elderly, or members of ethnic, faith or cultural groups on a whole host of activities designed to increase participation and involvement. From consultation about project ideas to inviting different audiences to curate exhibitions, the traditional 'top-down' authority

relationship is shifting so that curatorial expertise is informed by public knowledge, ideas and consultation to create interpretation that is audience-led. Initiatives may range from comic-book exhibition guides produced by young people, such as 'Creative Consultants' at Manchester Art Gallery, to popular 'Write Your Own Labels' schemes where the public can comment on pictures and exhibits and the most interesting responses are displayed alongside more traditional text produced by curatorial staff.

Alongside heightening a sense of ownership, such approaches can uncover and exploit public knowledge of collections, as well as contributing 'people' stories that are now seen as vital in bringing objects to life. The key is in the variety of activities and types of explanation on offer, designed to appeal to a range of audiences from children to older people, while also allowing for the existence of different individual learning styles. While some people may learn more from hands-on activity, and others from reading museum guidebooks, the increased use of multimedia and audio-visual displays continues to widen the possibilities of what museums can offer despite the fact that such technology can be expensive to buy and maintain. In addition, 'live interpretation' is sometimes being used in traditional museums and galleries to complement object displays, text panels, video installations, computer interactives and reconstructed settings such as historic rooms. While forms of live interpretation such as handling objects, lectures, guided talks and tours and the demonstration of skills and processes have a long history, traditional museums have also begun to make use of interpretation and re-enactment by costumed interpreters, sometimes trained actors – although cost often limits this to special events. The approach has long been the staple of open-air museums and heritage centres such as Beamish and the Wigan Pier Experience (now closed), where costumed trained staff and actors play parts from mine workers to music-hall performers, even extending to full re-enactments such as the Jorvik Centre-sponsored battle at the annual Viking festival in York. Such methods of telling real stories through fictional activity are now reasonably commonplace in museums, ranging from education officers dressing up and playing a part, to trained actors interacting with visitors with dialogue about the displays, to full scripted performances about objects or exhibitions, themes or stories not presented in permanent displays.

Hearing about people from people. In this early 1980s scene from the Weald and Downland Open Air Museum, volunteer steward Joan Brook tells visitors about the site, guidebook in hand.

While such approaches have been criticised for undermining the centrality of objects and strictly fact-based interpretation, this highlights the now-vital role of empathy and emotion in museum education and interpretation and a wider recognition that history is as much, if not more, about people as it is about objects and the physical traces of the past. As museums seek for different ways to represent and evoke the gamut of human experiences, using tangible and intangible heritage from objects to memories, oral history has become an important aspect of interpretation and display. While places such as the Imperial War Museum (London) and the St Fagans National History Museum (formerly the Welsh Folk Museum/Museum of Welsh Life) have longstanding oral history collections, first-person testimony is now perceived as more than an add-on, particularly with the use of video interview footage. One example is the People's Story Museum in Edinburgh (1989), a museum based on oral history and reminiscence work where objects were collected from local people who then worked with curators to research and write labels, bringing once-anonymous objects to life. The upsurge of community-based oral-history work through the 1980s and 1990s, backed by grants from organisations such as the Heritage Lottery Fund, further enhanced the possibilities for museums and the communities they represent, giving a whole new possibility for interpreting collections, particularly the more dry or technical and objects still extant in living memory. More poignant still, it is hard to imagine the Imperial War Museum's Holocaust Exhibition, which opened in 2000, evoking the same insight, emotion and impact without the filmed testimonies of eighteen survivors of Nazi persecution, many of whom witnessed family members perishing in ghettos and concentration camps.

As the role of museums widens, so too does their advance into the realms of popular culture. The V & A's 'Kylie' exhibition of costumes and memorabilia held in February to June 2007 was the subject of some controversy and fervent accusations of 'dumbing down.'

Behind the scenes, many museums have also improved the management of their collections through the accreditation scheme of nationally agreed standards (1988; renamed Accreditation in 2004), which has involved consideration of what is collected and how it is stored and, more controversially, how to dispose of material no longer seen as useful to the museum's main function or everyday work. Many museums see contemporary collecting (of material in current use) as a vital aspect of their role, which has been matched by advances in conservation science and the on-going challenge of collections care. The advance of the internet has also had a radical and on-going impact on the way museums undertake their work – with virtual access through digitisation, online exhibitions and social

media enabling education of and engagement with audiences who may never even step through their doors. Meanwhile, a focus on skills and skills-based learning as well as visitor appeal has led in some places to experimentation with 'open stores' where collections or parts of collections are on show to the public, either permanently or as part of a special tour.

Looking outwards, the twin pressures of competition and sustainability have forced museums to adopt a more commercial approach, taking a cue from tourism and marketing. Initiatives range from branding, target marketing, annual passes and joint ticketing across sites to family-friendly events programmes, corporate hire and larger promotional schemes such as London's 'Museum Mile,' involving a dozen of the city's most famous museums and galleries. As visitor numbers rise, aided by free admission to the nationals, proactive audience development and improved marketing, so too does spending – little could Elias Ashmole have imagined that in 2009 the contents of his cabinet of curiosities, some acquired from the Tradescants centuries before, would be housed in a refurbished Ashmolean Museum at a cost of £61 million.

Although the past two centuries have witnessed numerous developments and innovations, many challenges remain. The rapid rate of technological advance, particularly new digital learning technologies, and the difficulty of keeping pace with this and meeting visitor expectations in an increasingly competitive world can place pressure on interpretation and exhibition planning and museum budgets, particularly in smaller and volunteer-run venues. Likewise the storage and conservation of seemingly ever-increasing collections amassed by several generations is a perennial problem, while debate over critical issues such as the repatriation of objects and the restitution of human remains to their countries of origin, rumbles ever on. On a more practical level, revenue generated by visitor admission fees, cafés and shops may be insufficient to adequately meet running costs in a sector where funding is often project-based or reliant on personal bequests, and local authority support is limited for non-statutory services. In common with the charity sector as a whole, the place of goodwill is paramount, with countless museums unable to open to the public without volunteers willing to undertake unpaid work, which in turn creates tasks of volunteer recruitment and management. Ironically, while museums in the twenty-first century appear to be more popular than ever, retaining the cultural pre-eminence bestowed by the Victorians, many venues – especially the quirky, independent, regional and publicly funded – remain under threat.

Volunteers at the Ryedale Folk Museum, led by Robin Butler, hauling a collection of chairs through the museum grounds.

PLACES TO VISIT

For a more comprehensive list of British museums and galleries see the *Museums and Galleries Yearbook*, published by the Museums Association or the Culture 24 website: www.culture24.org.uk

Ashmolean Museum, Beaumont Street, Oxford, Oxfordshire OX1 2PH.
 Tel: 01865 278000. Website: www.ashmolean.org
 The world's first university museum, built to house the collection donated to the University of Oxford by Elias Ashmole in 1677.
Beamish Museum, Beamish, County Durham, County Durham DH9 0RG.
 Tel: 0191 370 4000. Website: www.beamish.org.uk
 Large open-air museum, focusing on life in the north of England in the nineteenth and early twentieth centuries.
Birmingham Museum and Art Gallery, Chamberlain Square, Birmingham
 B3 3DH. Tel: 0121 303 2834. Website: www.bmag.org.uk
 Exceptional municipal museum and art gallery, founded in 1885.
Blist's Hill Victorian Town, Legges Way, Madeley, Telford, Shropshire TF7 5DU.
 Tel: 01952 884391. Website: www.ironbridge.org.uk
 Open-air museum of Shropshire industry and everyday life, run by the Ironbridge Gorge Museum Trust.
Bowes Museum, Barnard Castle, Durham DL12 8NP. Tel: 01833 690606.
 Website: www.thebowesmuseum.org.uk
 Palatial purpose-built public art gallery and museum, opened in 1892.
British Museum, Great Russell Street, London WC1B 3DG.
 Tel: 020 7323 8000. Website: www.britishmuseum.org
 National museum of human history and culture, established in 1753.
British Lawnmower Museum, 106–114 Shakespeare Street,
 Southport, Lancashire PR8 5AJ. Tel: 01704 501336.
 Website: www.lawnmowerworld.co.uk
 Nation's foremost museum of garden machinery.
Brontë Parsonage Museum, Church Street, Haworth, Keighley, West Yorkshire
 BD22 8DR. Tel: 01535 642323. Website: www.bronte.org.uk
 Former home and museum tracing the life and work of celebrated writing family, the Brontës.
Charles Dickens Museum, 48 Doughty Street, London WC1N 2LX.
 Tel: 020 7405 2127. Website: www.dickensmuseum.com
 Only surviving home of Victorian author Charles Dickens.
Dove Cottage, The Wordsworth Museum and Art Gallery, Town End, Grasmere,
 Cumbria LA22 9SH. Tel: 015394 35544.
 Website: https://wordsworth.org.uk
 Home of the poet William Wordsworth and museum of his life and work.

Dulwich Picture Gallery, Gallery Road, Dulwich Village, London SE21 7AD.
Tel: 020 8693 5254. Website: www.dulwichpicturegallery.org.uk
England's first purpose-built public art gallery.

Fitzwilliam Museum, Trumpington Street, Cambridge,
Cambridgeshire CB2 1RB. Tel: 01223 332900.
Website: www.fitzmuseum.cam.ac.uk
Art and antiquities museum of the University of Cambridge,
based on the bequest of the 7th Viscount Fitzwilliam.

Foundling Museum, 40 Brunswick Square, London WC1N 1AZ.
Tel: 020 7841 3600. Website: www.foundlingmuseum.org.uk
The nation's first public art gallery and part of the now defunct
Foundling Hospital for abandoned children.

Horniman Museum and Gardens, 100 London Road, Forest Hill, London
SE23 3PQ. Tel: 020 8699 1872. Website: www.horniman.ac.uk
Museum founded by tea trader and philanthropist Frederick John
Horniman, opened to the public in 1901.

IWM London (part of Imperial War Museums), Lambeth Road, London
SE1 6HZ. Tel: 020 7416 5000. Website: www.iwm.org.uk
The London branch of Imperial War Museums, with other venues
nationwide, notably Salford's IWM North.

Manchester Museum, The University of Manchester, Oxford Road,
Manchester M13 9PL. Tel: 0161 275 2648.
Website: www.museum.manchester.ac.uk
University of Manchester Museum specialising in archaeology,
anthropology and natural history.

Museum of Brands, Packaging and Advertising, 2 Colville Mews, Lonsdale
Road, Notting Hill, London W11 2AR. Tel: 020 7908 0880.
Website: www.museumofbrands.com
Home of an extensive and colourful collection started
by Robert Opie.

Museum of London, London Wall, City of London EC2Y 5HN.
Tel: 020 7001 9844. Website: www.museumoflondon.org.uk
Museum tracing the history of London from the prehistoric to the present.

Museum of Science and Industry, Liverpool Road, Castlefield, Manchester
M3 4FP. Tel: 0161 832 2244. Website: www.mosi.org.uk
Part of the Science Museum group, focusing on the development
of science, technology and industry alongside Manchester's
industrial heritage.

Museum of Witchcraft, The Harbour, Boscastle, Cornwall PL35 0HD.
Tel: 01840 250 111. Website: www.museumofwitchcraft.com
The world's largest collection of witchcraft and wiccan related
artefacts, established by neopagan witch, Cecil Williamson.

National Gallery, Trafalgar Square, London WC2N 5DN.
Tel: 020 7747 2885. Website: www.nationalgallery.org.uk
National collection of Western European painting from the thirteenth
to the nineteenth centuries, founded in 1824.

National Museum Cardiff, Cathays Park, Cardiff, Wales CF10 3NP.
Tel: 029 2057 3000. Website: www.museumwales.ac.uk/cy/cardiff
Founded in 1907 but not opened until 1927, specialising in
archaeology, botany, fine and applied art, geology and zoology.
Part of the wider network National Museum Wales.

National Museum of Scotland, Chambers Street, Edinburgh, Scotland
EH1 1JF. Tel: 0300 123 6789. Website: www.nms.ac.uk
Scottish national museum, amalgamating the former National Museum
of Antiquities and the Royal Scottish Museum.

National Museums Liverpool, c/o 127 Dale Street, Liverpool L2 2JH.
Tel: 0151 207 0001. Website: www.liverpoolmuseums.org.uk
A group of free museums and galleries on Merseyside including the
World Museum, the Walker Art Gallery, the Lady Lever Art Gallery,
Merseyside Maritime Museum, International Slavery Museum, Sudley
House and the Museum of Liverpool.

National Railway Museum, Leeman Road, York, North Yorkshire YO26 4XJ.
Tel: 08448 153 139. Website: www.nrm.org.uk
Home to the UK's national railway collection, telling the story of rail
transport in Britain.

Natural History Museum, Cromwell Road, London SW7 5BD.
Tel: 020 7942 5000. Website: www.nhm.ac.uk
South Kensington museum, specialising in natural history in an iconic
Alfred Waterhouse building.

Old Operating Theatre Museum, 9A St Thomas' Street, London SE1 9RY.
Tel: 020 7188 2679. Website: www.thegarret.org.uk
Atmospheric museum of surgical history, including one of the oldest
surviving operating theatres and an apothecary's herb garret.

Oxford University Museum of Natural History, Parks Road, Oxford, Oxfordshire
OX1 3PW. Tel: 01865 272950. Website: www.oum.ox.ac.uk
Museum of the University of Oxford housing the university's scientific
collections of zoological, entomological and geological specimens,
housed in a spectacular neo-Gothic building.

Pitt Rivers Museum, University of Oxford, South Parks Road, Oxford,
Oxfordshire OX1 3PP. Tel: 01865 270927. Website: www.prm.ox.ac.uk
Museum of the University of Oxford specialising in archaeology and
anthropology, founded by Lieutenant Colonel Augustus Pitt Rivers.

Powell-Cotton Museum, Quex Park, Park Lane, Birchington, Kent CT7 0BH.
Tel: 01843 842 168. Website: www.quexpark.co.uk/museum

Established by Major Percy Powell-Cotton in 1896 to house natural history specimens and cultural objects collected on expeditions to Asia and Africa.

Royal Armouries, Armouries Drive, Leeds, West Yorkshire LS10 1LT. Tel: 08700 344 344. Website: www.royalarmouries.org/home
Britain's national museum of arms and armour, across three sites including the Tower of London, Fort Nelson in Portsmouth and a headquarters in Leeds.

Royal Museums Greenwich, Park Row, Greenwich, London SE10 9NF. Tel: 020 8858 4422. Website: www.rmg.co.uk
Three linked sites: the National Maritime Museum, the Royal Observatory Greenwich and the seventeenth-century Queen's House, set in Maritime Greenwich World Heritage Site.

Ryedale Folk Museum, Hutton-le-Hole, York, North Yorkshire YO62 6UA. Tel: 01751 417367. Website: www.ryedalefolkmuseum.co.uk
Yorkshire's leading open-air museum.

Science Museum, Exhibition Road, London SW7 2DD. Tel: 0870 870 4868. Website: www.sciencemuseum.org.uk
The UK's major science museum, with sister sites nationwide.

Sir John Soane's Museum, 13 Lincoln's Inn Fields, London WC2A 3BP. Tel: 020 7405 2107. Website: www.soane.org
The cornucopic collection of architect Sir John Soane, bequeathed to the nation on his death in 1837.

St Fagans National History Museum, St Fagans, Cardiff, Wales CF5 6XB. Tel: 029 2057 3500. Website: www.museumwales.ac.uk/en/stfagans
Open-air museum representing the life and culture of Welsh people. Part of the National Museum Wales network.

Tate Britain, Millbank, London SW1P 4RG. Tel: 020 7887 8888. Website: www.tate.org.uk/visit/tate-britain
National gallery of British art from 1500 to the present day.

Tate Modern, Bankside, London SE1 9TG. Tel: 020 7887 8888. Website: www.tate.org.uk/visit/tate-modern
UK's national museum of modern and contemporary art from 1900 to the present day.

Ulster Folk and Transport Museum, Cultra, Holywood, Ulster NI BT18 0EU. Tel: 0 28 9042 8428. Website: www.nmni.com/uftm
Open-air museum focusing on Irish life in the nineteenth and early twentieth centuries.

V&A Museum of Childhood, Cambridge Heath Road, London E2. Tel: 020 8983 5201. Website: www.museumofchildhood.org.uk
Recently renovated Victorian museum tracing the social history of childhood with exhibits including toys and games from different eras.

Victoria and Albert Museum, South Kensington, London SW7.
Tel: 020 7942 2000. Website: www.vam.ac.uk
The national museum of art and design with vast collections
encompassing fashion, ceramics, textiles, furniture, fine art and more.
Wallace Collection, Hertford House, Manchester Square, London
W1U 3BN. Tel: 020 7563 9500. Website: www.wallacecollection.org
World-famous collection of Richard Seymour-Conway, 4th Marquess of
Hertford bequeathed to the nation by the widow of his illegitimate son,
Sir Richard Wallace.
Wayside Museum, Zennor, near St Ives, Cornwall TR26 3DA.
Tel: 01736 796945. Website: www.museumsincornwall.org.uk/
Wayside-Museum-and-Trewey-Mill,-Zennor/Cornwall-Museums
Local museum and mill telling the story of farming and local life.
Weald and Downland Open Air Museum, Singleton near Chichester, West Sussex
PP018 0EU. Tel: 01243 811363. Website: www.wealddown.co.uk
Picturesque open-air museum of Sussex life and building technology.

FURTHER READING

Timothy Ambrose and Crispin Paine, *Museum Basics* (Routledge, 2012)
Tony Bennett, *The Birth of the Museum: History, Theory, Politics*
(Routledge, 1995)
Graham Black, *Transforming Museums in the Twenty-first Century*
(Routledge, 2011)
David Boswell and Jessica Evans (eds.), *Representing the Nation: A Reader:
Histories, heritage and museums* (Routledge, 1999)
Bettina Carbonell (ed.), *Museum Studies in Context* (Blackwell, 2003)
Gerald Corsane (ed.), *Heritage, Museums and Galleries: an Introductory Reader*
(Routledge, 2005)
Kate Hill, *Culture and Class in English Public Museums, 1850–1914*
(Ashgate, 2005)
Eilean Hooper-Greenhill, *Museums and Their Visitors* (Routledge, 1994)
Eilean Hooper-Greenhill, *The Educational Role of the Museum*
(Routledge, 1999)
Sharon Macdonald (ed.), *A Companion to Museum Studies* (Wiley-Blackwell,
2010)
Simon Tait, *Palaces of Discovery: Changing World of Britain's Museums* (Quiller
Press, 1989)
Kevin Walsh, *The Representation of the Past: Museums and Heritage in the
Post-Modern World* (Routledge, 1992)
Museums Association website: www.museumsassociation.org and its journal
publications *Museums Journal* and *Museum Practice*.

INDEX